# Chris Packham's
# WILD SHOTS

# Chris Packham's
# WILD SHOTS

**A new look at photographing the wildlife of Britain**

C&B
COLLINS & BROWN

**Dedication**

*All these capsules of foreverness are for the dropped angel.*

First published in Great Britain in 1993
by Collins & Brown Limited
Letts of London House
Great Eastern Wharf
Parkgate Road
London SW11 4NQ

1 3 5 7 9 8 6 4 2

British Library Cataloguing-in-Publication Data:
A catalogue record for this book
is available from the British Library.

ISBN 1 85585 189 X (hardback edition)
ISBN 1 85585 200 4 (paperback edition)

Conceived, edited and designed by Collins & Brown Limited

**Editor:** Sarah Hoggett
**Art Director:** Roger Bristow
**Designed by:** Ruth Hope
Filmset by Servis Filmsetting, Manchester
Reproduction by Scantrans, Singapore
Printed and bound in Great Britain

# CONTENTS

# INTRODUCTION

M y parents tell me that my first gurgled word was 'dirdies', an approximation for the starlings that cackled above my afternoon dozing position in our suburban garden. Wildlife has remained a fascination for me ever since, whilst lesser rivals have come and gone. I enjoy learning the habits of animals and plants, understanding how each fits so neatly into its niche and ecosystem, but more importantly I enjoy them because of the way they look, sound and smell.

I was eight or nine years old when I juggled a dead starling I had found in the gutter on the main road. I knew nothing then of his habits, the names for all his feathers, how he flew, when and why, his scientific name, or how many eggs of what colour his mate had hidden under a nearby eve. But I knew he was one of the most beautiful things I had ever seen. Not exotic, not rare, not hard to see, a fabulous example of Blake's proclamation that we can 'see the world in a grain of sand and heaven in a wild flower' if we take the trouble to 'hold infinity in the palm of our hand and eternity in an hour'. I was captivated by the perfection evident in each wing, feather, tiny barb and vein all honed by millions of years of relentless design.

## Breaking with the past

Why is it, then, that things such as the miraculous beauty of a dead starling, a minuscule fractal of nature's available resource, took so long to excite the world's wildlife photographers? Landscapes, yes, but plants and animals, no. In the very earliest days of photography primitive equipment and fickle film hampered photographing anything that moved, but photographic science was fast developing and soon a few pioneers were inventing their own solutions to wildlife problems. The 1890s saw new 'instantaneous' pictures using the dry-plate process and by the early 1900s the rich and titled were indulging themselves on opulent photographic safaris throughout Africa. Martin and Osa Johnson thought nothing of carrying innumerable cameras, thousands of pounds worth of lenses, chartering an aeroplane each and—to help out a little—hiring 130 bearers. Such snappers were frequently snapped at themselves, and heroic stories of lion, leopard and elephant encounters fill a bevy of safari photobooks.

Here I think is the root of the problem—romanticism. Photography was born in an age of romance but wildlife photography has only recently grown out of it. The incredible stamina needed by pioneer photographers to get close to and then record a wild subject was, indeed is, interesting. These days, however, everything is much easier, yet how many times do you read of 'suffering' in wildlife photo captions? It's as if it is a prerequisite for good photography. Captions, too, can take up as much space on the page as the photos themselves. Thus hiding behind this shroud of 'cleverer than thou'

romantic nonsense, the world's richest aesthetic resource was damned to illustrative reportage.

## Artistic licence

FOR ONE REASON or another, photographs are sometimes less than entirely truthful in being a record of an undisturbed nature. The photograph here shows five hedge sparrow eggs in their nest. Not quite as common as the starling, there will probably be, however, one of these birds nesting in a hedgerow near you in April or May. They are brown, skulking and have a pretty twitter of a song—quite average until you pull back the brambles to find the little hair-lined cup they have surrounded with mosses and tiny twigs to use as a nest. With schoolboy's bird-nesting skills still intact, I set out and found a nest deep in a dark briar beyond the reach of my lens and in foliage so dense the nest would need to be destroyed to illuminate the eggs. What you see printed here is in fact a replica of my vision, a piece of artistic licence. They are in reality duck's eggs, sprayed with car paint and laid on a tray under a tent of tracing paper to soften the daylight entering my dining room. I could have lied. I could have told you that the picture was of dunnock's eggs in a musty English hedgerow lit by rays of early spring sunshine. But why?

My object was to reproduce reality in a two-dimensional form, to produce a work that would celebrate a fraction of that reality, to transcend photography and produce a picture of nature. The photograph should be judged by its success in this sphere alone, not by its caption.

## Discovering a personal approach

THE AIM of this book is simple—to stimulate budding wildlife photographers to look in a new way at subjects in their own back gardens and to concentrate on art as well as the subject. Keep your eyes—and your mind—open to all kinds of visual experience. Borrowing ideas and styles of approach from the established art movements is all part of an enriching process of cross-pollination. If your taste is in Impressionism, replicate that approach in your own style on film: pin-sharp record shots can be transformed into beautifully lit, unsharp shapes alluding to a visual recollection of how you truly see a subject. Abstraction is yours simply by cropping in tight on any subject—the shape of its fur, the pattern or colouring of its scales or feathers, even its decaying corpse can be beautiful in its own right without you ever needing to identify the species. By excluding all but your subject, or part of it, on an

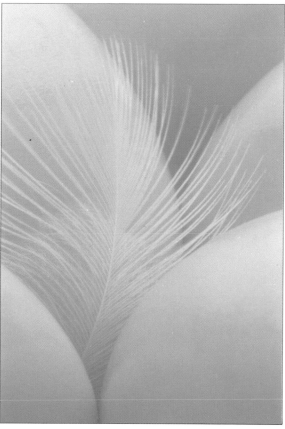

**Duck egg blue**
*The yolk of a fresh-laid dunnock's egg seems to absorb and re-emit light like a little bulb, enhancing the blueness of its unblemished shell. Little capsules of bird made of sky. It was this fragile blue and its gently curving shell that I wanted to record, but not at the expense of destroying the only dunnock's nest I could find. What you see here are duck's eggs, painted blue, and arranged in a nest of my own construction set up on my dining-room table. A 100mm macro lens has cropped them to form an abstract sculptural eggscape.*

otherwise empty frame you can have Minimalism in a minute. Having been exposed to a lifetime of strictly illustrative natural history photographs, one way to concentrate your efforts in this regard is to set yourself an assignment—say, ten impressionist views of a local park, all taken within a realistic timespan.

## Something from nothing

NOT ALL the photographs in this book aspire to high art—some are standard and simply pleasing, some are the result of everyday tricks, while others are nothing more than gimmicks that have separated them from the normal school of nature photography. The photograph that really encapsulates the ethos behind some of the photographs in this book is the dustbin view of an urban fox (below right). Although it is technically imperfect—the fox is soft and the interior of the bin could have been better lit—it is a different angle on a very common subject, taken not in some exotic tropical rainforest but from my parents' kitchen window. All you need do is see things in a different way. With this fox photograph, the simplicity of a different viewpoint—

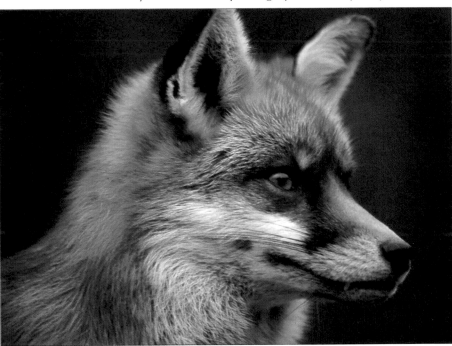

**Tunnel vision**
*A young fox regularly raiding my parents' garbage became the subject of this shot (right). After kicking the bottom out of an old rusty dustbin, I arranged specially collected clean rubbish and stapled it into position. Chicken and chocolate buttons ensured the star turn's presence and the set was lit from the kitchen window. I shot six successful frames using a pneumatic release while standing rather uncomfortably on the fridge behind a curtain. This is my type of photograph: some thought has gone into it, some expense; no suffering was involved for either me or the subject; and more informative than a conventional, static portrait of a foxes head, such as the one I took above.*

contrived by kicking the bottom out of an old rusty bin and baiting the area with tasty titbits—has created a picture from an ordinary scene and made it a winner. A gimmick has made something from nothing. Furthermore the gimmick paid off, because this photograph was awarded first prize in one category of the Wildlife Photographer of the Year competition in 1986. That is certainly something the altogether more prosaic fox portrait (below left) could never hope to do.

## Abstracting reality

ANOTHER TWO of my pictures, that of a dead fish head (see pp. 10–11) and the rear end of an otter (see pp. 14–15), are both prizewinners, for what it is worth, and by simply using some photographic skills and minimizing the detail to an abstract form something has emerged from a normally disregarded source. These two photographs concentrate on an aspect of each creature's form and say little about its ecology, but often it is necessary to depict an animal or plant in its natural environment to explore fully its photographic potential. By expanding the frame more information can be

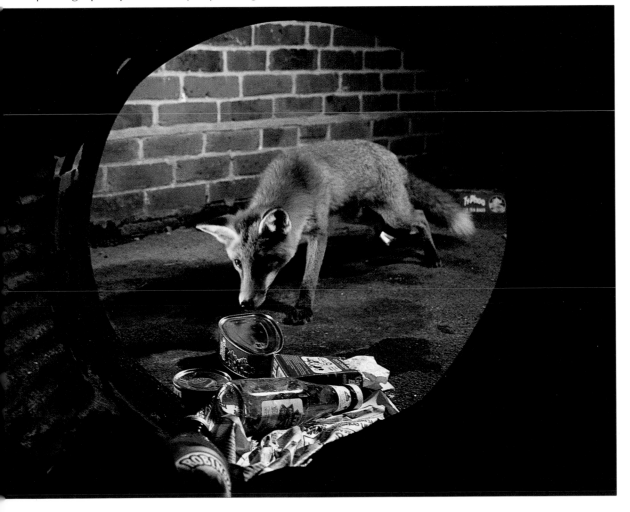

**Fossilized fish**
*In fossil collections worldwide you can see the sculptured outlines of extinct fish pressed into stone and hung like marvellous tiles over musty museum walls. It was this image that I envisaged for my trophy—a dead fish head recovered beneath the gannet-clad cliffs of the Bass Rock near Berwick in Scotland. The beautiful natural texture of scales, gills and lips survived the process of putrefaction, and to exaggerate this texture I sprayed the head from one side with gold paint and from the other with matt black. To enhance the texture even further, lighting was very oblique sunlight bounced off a gold-foil reflector.*

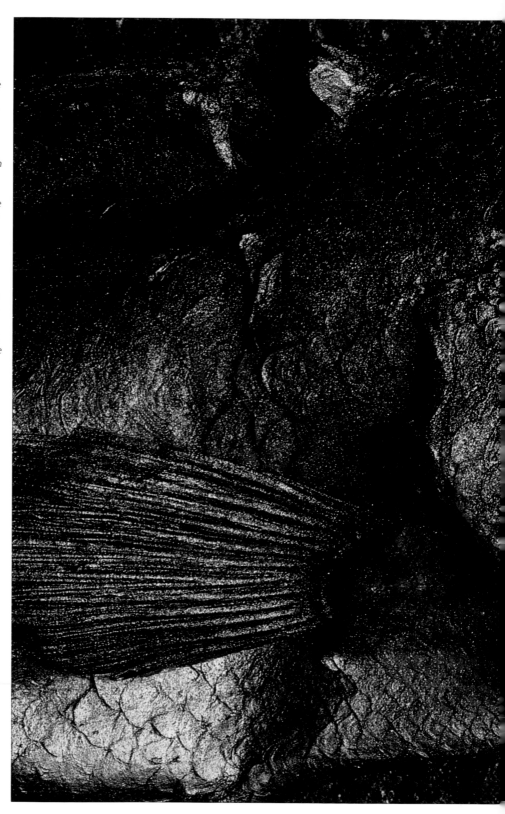

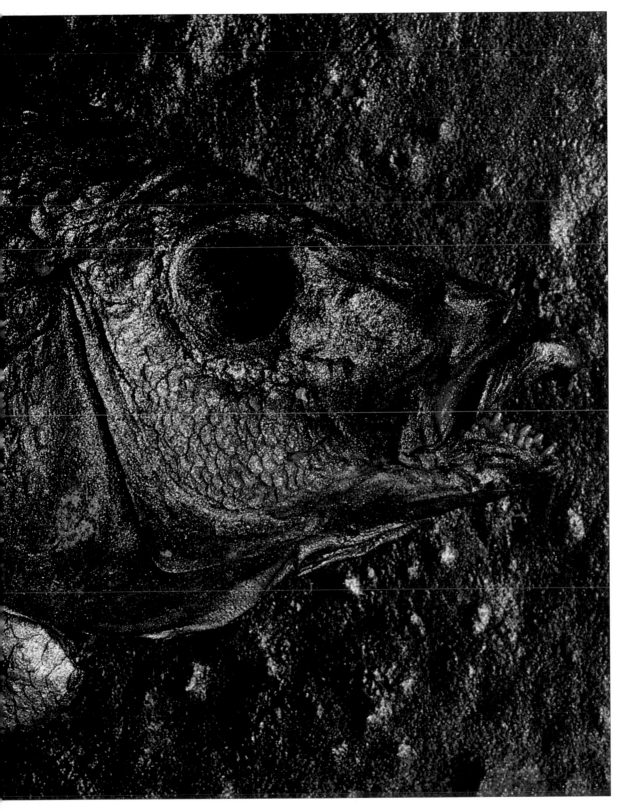

recorded, making the photograph increasingly like reportage or documentation. If you sacrifice your artistic eye then all is lost, but if you can skilfully combine the two objectives a better photograph will result.

## Learning your craft

WHEN I first started taking photographs I used to set myself projects to fulfil. This was a good way of focusing my undeveloped skills on a topic and forcing myself to look at the subject in more detail. At the same time, the process revealed my technical weaknesses, forcing me to solve these in order to produce a successful result. Reflections made up the subject of one such project and several of these photographs appear in the book. The spirit of woodland was another, and all of the best shots from this self-assignment appear in the Plants chapter. The photograph reproduced here (right), though, is a simple 'one-shot wonder' to illustrate the decline of sandy lowland heath, which is a habitat I have explored all of my life and one that I like the feel of. This type of heathland, now confined to the south of England in a sad patchwork of fragments, is one of Britain's most threatened habitats. Afforestation, agricultural reclamation and urban development have all taken their toll. It is, quite simply, a dying habitat, and the photograph shown here was designed to illustrate this. For many years heathland was maintained and prevented from turning into forest by the grazing of sheep, and I wanted to illustrate how the decline of this practice, amongst other things, has affected the habitat. I have tried to go one step beyond the normal 'burned heath with building site' documentary approach and convey an idea, a sense of the desolation.

This photograph is obviously contrived. Many of the photographs in this book are even more orchestrated, and many include living subjects. This approach is obviously contentious. Many people believe that wildlife photography should be of strictly wild subjects and that the skill is in the capturing of this wildness on film without interfering with reality. Quite obviously I am not of this school. I have developed my skills to select fragments of reality and to isolate these as quickly and as effectively as possible. Rather than debate this issue to its impossible non-conclusion, I have been frank and honest in the textual information relating to my photographs. You will have to make up your own mind about which side of the fence you feel most comfortable on. There is, however, one overriding proviso to all schools of wildlife snappers: the wellbeing of the subject is paramount. Never, ever harm your subject. If you don't love it, don't use it; if you do love it, don't lose it.

## What is good wildlifle photography?

ALTHOUGH ACCOMPLISHED in their aims, some pictures are simply not my type of photograph, and indeed the shot of a golden eagle on pages 16–17, albeit dramatic, symbolizes almost everything I dislike about most 'good' bird photography. The bird is frozen, deathly still, sapped of the motion that makes its flight almost a miracle. You could never see this in real life because

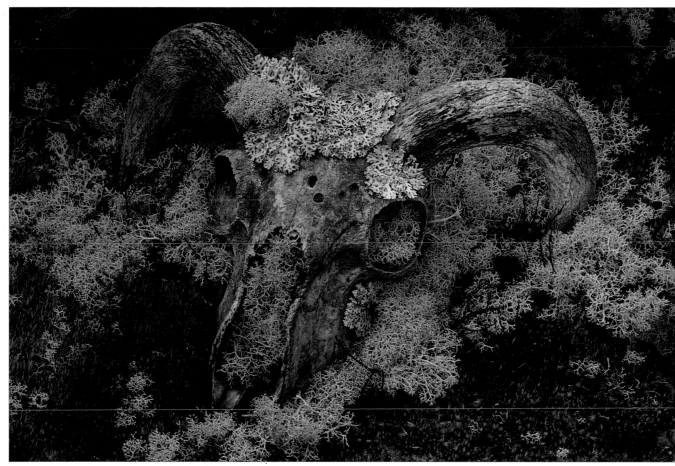

the human eye does not register images of this type. Besides, how many of us have ever been this close to such a raptor in the wild? As it is, this eagle is about to seize its prey a few feet from the camera. I have seen many wild golden eagles, I have watched them wheeling, soaring, swooping in silhouette against far-off rock screes and slate grey Scottish skies, but I have never seen the twinkle in their eyes, or even the eye itself. And I would not have seen it this time either had the shot not been set up in the studio.

From a bird anatomist's point of view I suppose it is quite interesting to see the wings at work, the fanned tail acting as a brake, those talons spanned for a sharp spread of death, and the head thrust forward into the impending action ready to steer the gruesome proceedings. Perhaps most surprising of all, though, is the length of the legs. Stretching from midway up the chest they are twice as long as you see them when the bird is perched. I would rather see a poorly lit blur that smells of heather, peat and rain, though.

## A camera is just a tool

I FIND TALK of equipment tedious. Just because cameras and lenses are more complex and expensive than spanners and screwdrivers does not make them any more exciting. Of course, there are better quality, longer lasting and

**A dying habitat**
*Afforestation and urban sprawl have fragmented and largely destroyed our heathlands. For many years heathland was prevented from turning into forest by the grazing of sheep, a practice now all but discontinued. To illustrate this, I placed an old ram's skull among the lichen. I pushed some lichen into the nasal cavities and eye sockets and glued some more scraps to the cranium. The gloom of a rainy day has increased colour saturation and the result is a simple still life to tell of the heathland's sad demise.*

13

**Minimal content**
*This photograph is one of many I took in a period of extreme abstraction. Getting this close to an otter in the wild is impossible, and this animal was snapped at an otter sanctuary in Suffolk. Even in captivity, however, their frenetic activity makes them difficult to photograph, particularly since their enclosures give you little scope for making the setting look natural. At the end of an unsuccessful day's shooting, with only a few frames left in the camera, I leaned over the fence and pointed my 70–210mm zoom lens directly down on this tame, resting individual.*

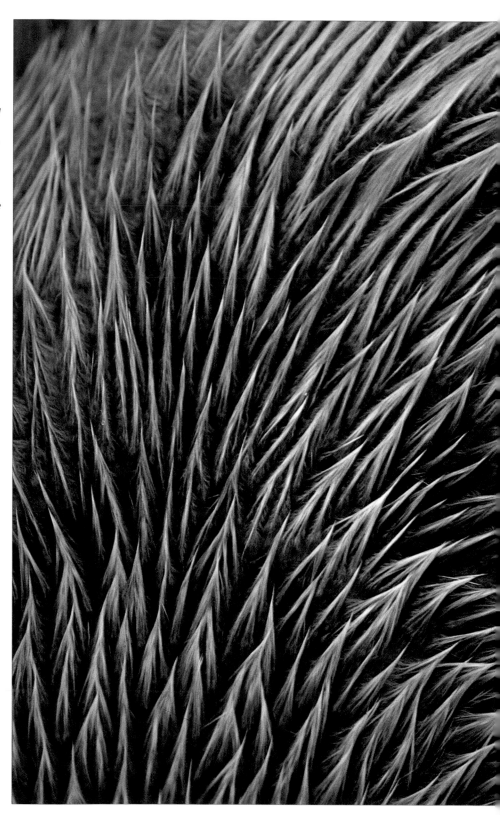

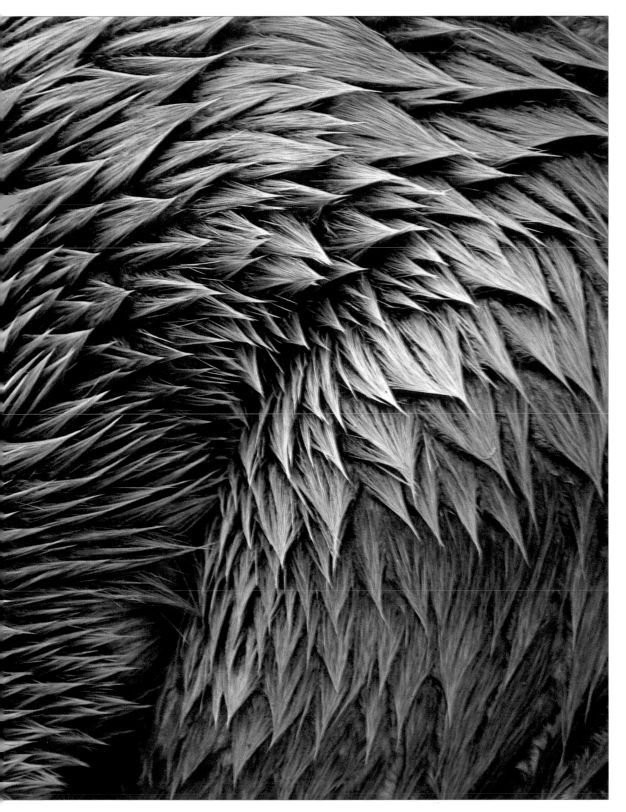

**Commercial commission**
*Commissioned by a company whose logo features an eagle in exactly this position, this shot was taken in the studio with the help of the Hawk Conservancy at Weyhill and Sebastian the golden eagle. The bird was released from the top of a ladder for a steep jump down to a perch baited with food. He happily performed this 10 or 12 times over two nights. I used a 6 × 7cm camera and lighting was provided by a hired high-speed flash kit. The client was very pleased with the result.*

**Bird portrait**
*In many respects this image of an eagle owl is similar to that of the golden eagle—sharp, properly exposed, pleasantly lit and nicely positioned in the frame. I have seen thousands of bird portraits like this, and many better!*

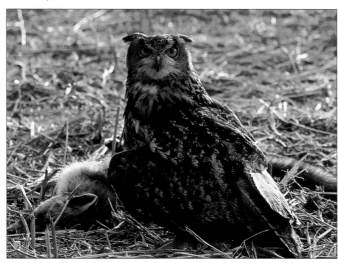

more versatile versions of spanners and screwdrivers—and cameras—but choosing a particular model comes down to personal preference and how much you can afford.

Nevertheless, whilst spanners have changed little in the past hundred years, cameras evolve seasonally and consequently ensnare the fashion conscious in expensive plays of renewal. If you must have the latest gadgets then at least limit yourself to a range of equipment you will actually use. While real technical purists may have telephotos of all focal lengths between 100mm and 500 or 600mm, because zoom lenses do not perform as well optically, they will also need the biceps of a body builder to carry them all around and no doubt miss opportunities as they swap one lens for another more suitable one for a shot.

To be honest, I have a pile of glassy black bits that look good gathering dust, but I have realized my mistake and 28mm, 50mm, 100mm macro, 70–210mm zoom, 400mm telephoto lenses, ×2 converter, some extension tubes and a polarizing filter form the 364-day-a-year basis of my kit. I use these with winders occasionally, with the stoutest tripod I can carry. I often defeat the object of my spartan hardware by overloading with spare everythings, especially cable releases, which I always leave, or lose, or fiddle with and destroy. The lenses are well padded inside my bag, but my Canon

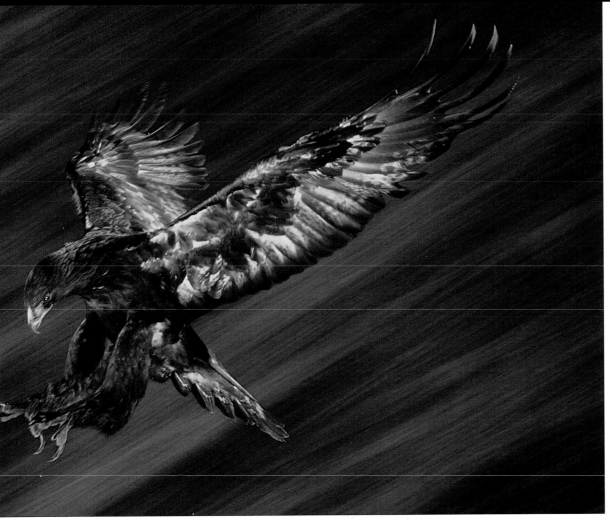

cameras swing freely outside. No camera ever snapped a great shot from inside the bag! I prefer a few scratches and regular cleaning to missed opportunities.

## Personal preferences

WHY CANON? Top quality, an extensive range of equipment, proper servicing facilities, good value for money, lots of second-hand items about and very robust. Indeed, I once dropped my old Canon F-1 camera into salty water and mud. I seriously considered hari-kari but chose instead to wash, dry and re-battery the old monster. And it worked. It is still working. I must admit to liking the manualness of the now obsolete F series Canons and their excellent FD lenses, but this taste may be prejudiced by the expense of switching to the new and awesome EOS range of equipment. These electronic beauties have auto-everything. They are also robust and perfectly designed to operate in front of the eye—no more lap gazing at tricky old dials. Autofocus is practically essential if you want to photograph animals in motion, and the technology available is remarkable. Lenses snap sharp on the moving subject in a fraction of a second, follow focus as the subject careers across the viewfinder and the whole procedure is almost silent. The choice is yours, however, and I will not become involved in camera snobbery.

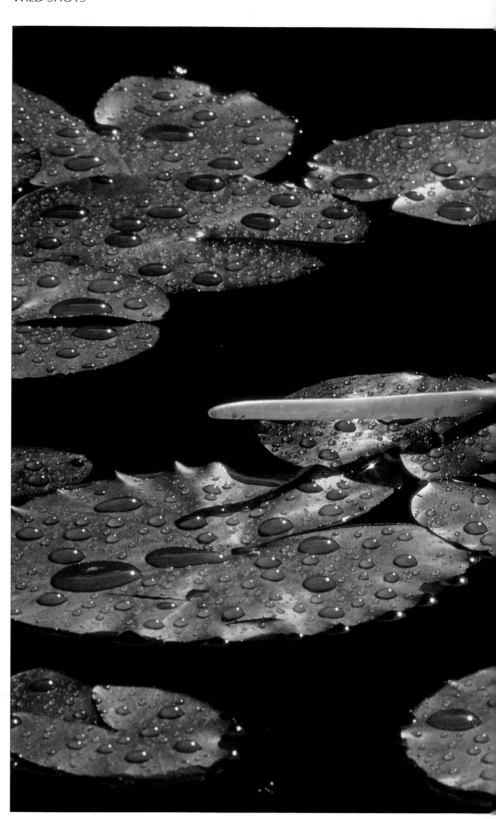

**Sculptural light**
*Light is the sculptor here. Taken in changeable stormy daylight, the shot is clear, sharp and fresh. The sudden emergence of the sun from behind the clouds has turned the water nearly black. The lily pads, seconds before looking like melted pools of green, now have the appearance of islands, and the water droplets have begun to harden into mercurial blobs.*

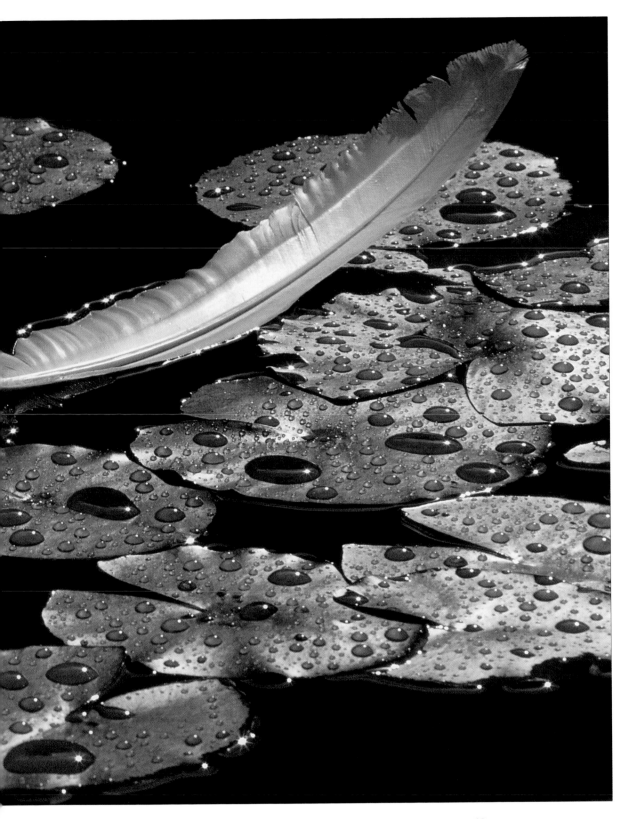

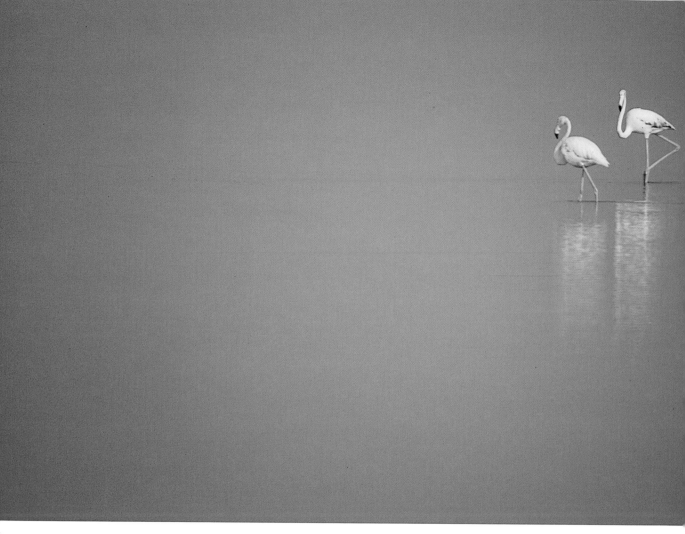

## A niche of one's own

THERE IS a whole clique of well-equipped and experienced bird photographers who consistently produce 'crippling' but uninteresting portraits of birds. Even to try to compete with them would be an insane and worthless task. Years of effort would be required to create replicas of their already outstanding work. No, embrace one of life's important rules and avoid competition at all costs. Carve a niche for yourself or explore one in which few others are active and enhance your chances of success by probability alone. Develop an ability and some style in that niche and you cannot fail. Use Darwin's theory of natural selection to evolve into a new species of wildlife photographer.

For good photography, the light has got to be on your side. Many years ago on a photographic trip to the Camargue I spent six weeks living on a beach. I shot a total of 16 rolls of film, and out of those 576 frames there are just two pictures of flamingos I am pleased with (above and overleaf). The

funny thing is that out of the hundreds of photographic forays I made, these photographs were just three frames apart on the same film, taken in the same place and at the same time.

## A coming of age

BY CHOOSING my life's obsession as a subject for my art I have taken on both an ally and an enemy. True, my pictures come from the heart; I have respect for all living things and this must ease the process of transferring them to film. It helps to have a subject you revel in. At the same time, however, it is also a hindrance. Transferring the full-blown wonder of nature to one frame of plastic is a difficult challenge—not one I have ever fully met. In some of my photographs I have captured aspects of an individual species' character in a static hardcopy, but living organisms are too big and complex for any photographer to be completely successful.

So why do I bother? Firstly, I hated wildlife photography rotting in the doldrums of artistic mediocrity and resented the snobbery that surrounded the field. I wanted to erode its cliquey myth and make a few artistic offerings to help lead it into the mainstream of photographic art. Secondly, and arrogantly, in the kingdom of the blind the one-eyed man is king—I may not be 20/20 in right and left, but I had no desire to replicate multiflashed blue tits on my birdtable. In nature, the only way to succeed is to avoid competition and to evolve into something new, and I have tried to do this—with a modicum of success. Fortunately I was not alone in this endeavour and since the mid-1980s a dramatic transformation has begun. It must conclude with wildlife photographers harnessing as much respect as the likes of Maplethorpe, Bailey, Hockney, Leibowitz and McCullin. It's up to you.

In the text accompanying the photographs in this book there is a mix of ecological anecdotes, personal trials and technical tips. There are few specific avenues or chapters of thought, and each group of photographs appears as a fairly isolated concept. Each can be approached fresh without any introduction. This is not a technical manual of wildlife photography, nor is it a natural history book of British flora and fauna. You will immediately note a dearth of photographs of mammals; a simple manifestation of the fact that I find them photographically unattractive. The shapes and forms of birds, insects and flowers I personally find more appealing. I hope that you will find at least a few of them stimulating and that, as a consequence, you will take a new look at wildlife photography.

**A change of viewpoint**
*Much of the Camargue is given over to huge, shallow salt pans known as étangs, and this photograph shows one as a perfect mirror for the ice-blue sky. As the flamingos timidly fled my inquisitive lens I shot off three quick frames, placing them high on the right for a pleasing composition. The bird nearest the edge is not that well positioned but I had no motor drive in those days. A surreal impression of two candy-legged loony birds paddling in the sky.*

**Backlit beauties**
*Taken just a minute after the loony birds on the previous page, this photograph shows gracious greater flamingos sifting for shrimps in an étang. About half a mile inland on one of the dykes I watched the sun rise behind this party of nine noisy birds. A 180° change of camera direction accounts for the lighting difference, and I shot them as silhouettes, using a 500mm mirror lens, their plumes ruffling in the breeze as they 'cronked' in the sparkling shallows.*

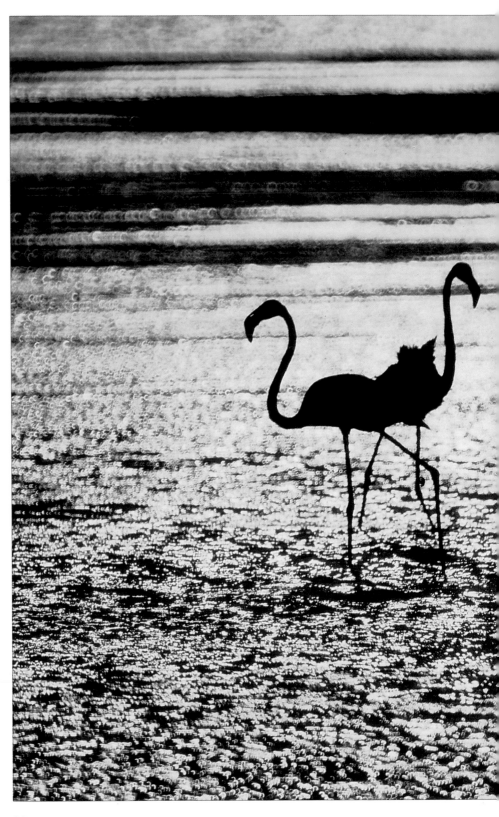

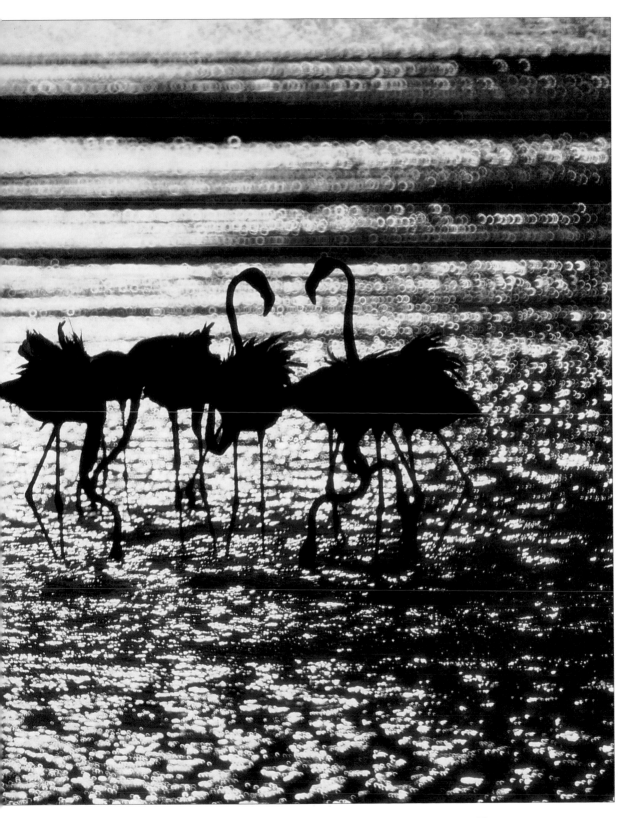

# BIRDS

STATE AGENTS, soldiers, welders, nurses, secretaries, bricklayers, footballers, filmstars and probably even popstars (although I've never met one yet) all fancy birds. Travelling halfway around the world to squint at them in a rainforest, traipsing down the local nature reserve on a Sunday morning, twitching on the Scillies or simply peering at them through the dining-room window, millions of people spend their leisure hours watching our feathered friends. In short 800,000 members of the Royal Society for the Protection of Birds cannot be wrong. Birds are our favourite form of wildlife and bird photography has a long, unhappy history.

Throughout the late 1800s, using horrible plate cameras and remarkably insensitive film, 'photographers' focused their lenses on stuffed specimens placed in wild situations. Despite the skills of the taxidermists, the results were ridiculous. As equipment and film improved, so did picture quality — but not as rapidly in this field as in the mainstream of photographic art. Indeed, any artistic approach was forfeited in favour of illustrative content. Getting the birds big in the frame, keeping them sharp and the exposure in order and, to really score, catching them in some unusual behavioural display, seem to have been the only objectives. Imagination was not a prerequisite for bird photographers as it was in other fields.

It was not until the 1980s, when a handful of photographers, both amateur and professional, began to give their subject secondary status and to introduce varying elements of individual style, that this strictly illustrative approach began to be challenged. The pioneers were led by the remarkable Franz Lanting, and his early photographs were a great inspiration to photographers like myself. A Dutchman who emigrated to California where he scooped a pile of photo contest prizes in the early eighties, Lanting now regularly shoots assignments for *Life*, *Geo* and the *National Geographic* magazines. I first encountered his work in a camera magazine nature supplement in 1983 and his silhouettes of waders, mosaics of sealions and eerie close-ups of dead owls' eyes and sharks' jaws not only put the contributions of other photographers in the shade, but stamped a firm artistic input into bird and animal photography. His book *Feathers* (published in 1982) has yet more striking images of an abstract and impressionist nature.

Of course, the potted history above is a generalization and there were exceptions, but they were few and far between. Happily, bird lovers' eyes have now opened to the myriad possibilities offered by a more artistic and inventive approach to bird photography and it is up to you to expand this still further. The following photographs show a few of my own attempts and

**Golden eagle**
*Canon F-1N, 70-210mm zoom lens, tripod with cable release, Ektachrome 100 Professional*

24

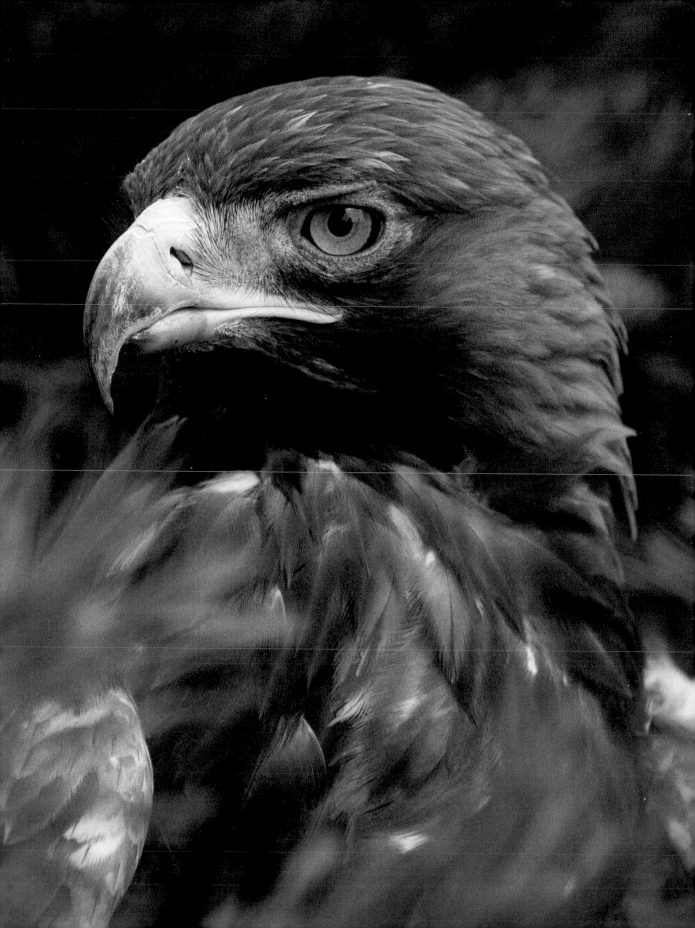

also illustrate some techniques to enable you to get interesting pictures of your favourite birds, beginning with my own greatest love — birds of prey.

# Portraits of Raptors

BY THE VERY NATURE of their profession, predators have to be a triumph of natural design. Their form is often purely functional; any decoration would prove too costly in the pursuit of prey. Study a cheetah and try to find some irrelevant feature, some appendage or other organ that it doesn't need. There are none. Such perfection is quite awesome. When the organism becomes airborne we reach the peak of contemporary predation — rapacious birds such as hawks, falcons and eagles.

An appreciation of raptors is not limited or new. The Ancient Egyptians venerated falcons 5000 years ago, eagles led the Roman Legions and decorated the war bonnets of Red Indians, and hawks were trapped and trained by the Chinese nearly 3000 years ago when they realized that these animals were more effective than any weapons they had by then invented. Thus the art of falconry was born, and although its popularity has waxed and waned, the practice continues today. As a consequence there are bird parks countrywide where raptors are bred, show and flown. Some are poor, run by cowboys (perhaps 'bird-boys' would be more appropriate), and should be shut down immediately. Others are well worth a visit. The very best, and I've seen a few, is the Hawk Conservancy at Weyhill in Hampshire. Here you will find an extensive, well-housed breeding collection featuring many exotic owl species and a similarly varied mews full of trained birds, all of which are regularly flown. The Conservancy concentrates on education and conservation, and its picturesque parkland setting makes it one of my favourite snapping grounds.

When I began to visit the Hawk Conservancy in 1983 to take photographs, I always telephoned in advance to see which species were in the mews and thus available to photograph. When I arrived I introduced myself and outlined my interests, but most importantly when I got my photos back I had a print made of my best effort and sent it to the proprietors. Over the years this approach, together with my increasing ability and unassailable enthusiasm, endeared me to the owners and we have become good friends. This type of modest, polite and professional attitude will win you nothing but kindness and help, and without Ashley Smith and Reg Smith at Weyhill the next two photographs would not have been possible.

Of course, the birds are captive, but how many of us can commit the time, or muster the ability, to learn about raptors and how to photograph them in the wild? By using the inexpensive facilities here at your leisure, with guaranteed subjects and the chance to repeat your attempts until you are satisfied, you avoid the risk of disturbing the birds, all of which are specially protected in the wild. Sitting in the shade of a birch tree watching a peregrine falcon preening itself for an hour is a fantastic way to comfortably study the physiology, behaviour, mood and shape of a normally elusive and fabulously

photogenic bird. You can then point your camera at a subject which will not bat an eyelid at your lens. It is a treat and a great training for the 'real thing'. One day you may acquire a licence to work on this species in the wild. You will travel miles and spend hours building hides and no doubt spend a fortune on your project too. If you don't know your bird, don't know what it looks like and can't predict how it will move and behave, you will almost certainly mess up your chance at 'big time'!

## Audience with a king

IN THE SHOT on p. 29, the peregrine was perched on a block in the mews, an open uncaged area where a number of birds sit during the day. Thus I had no problems with wire caging or enclosure supports behind the subject and, by reducing the background to a simple green and cropping tightly, I was able to remove any unnatural details. Not all captive conditions allow this. Enclosures are rarely designed with the photographer's needs in mind, and consequently special opportunities need to be arranged. Captive raptors are

### BRITISH BIRDS OF PREY

As MANY AS 24 species of diurnal raptors have been seen in Britain, but only 14 or 15 are regular breeders and the majority of these are quite rare. They are a compelling group — I defy anyone not to be stirred by the stare of an eagle, the wings of a falcon or the dashing of a hawk.

Britain's commonest bird of prey is the kestrel, that familiar motorway-hovering entrepreneur which now nests in the hearts of all our major cities, forsaking its country menu of voles and mice for a diet of squabbling starlings and sparrows. The rarest species are the honey buzzard or Montagu's harrier, both migrants that arrive to breed each summer having run the gauntlet of our European neighbours' senseless sporting guns. Few of these survive — perhaps as few as five or six breeding pairs of the secretive honey buzzards and a few more of the buoyant, field-quartering 'Montys'.

Sadly, all British birds of prey have suffered in the last two hundred years. After being revered for centuries as falconry birds, many species were hounded to the brink of extinction by gamekeepers in the 1800s, a practice which continues today in the form of illegal poisoning. The sea eagle, osprey and goshawk were beaten beyond the brink and vanished as breeding species until fairly recently.

In these post-pesticide days things look considerably rosier for our raptors; peregrines are back to numbers more typical of the Middle Ages, sparrowhawks have joined kestrels as urban bird snatchers and buzzards are slowly edging eastwards from their westerly retreats. Ospreys recolonized in the 1950s and after 40 years of consistent effort the RSPB has nurtured them back to a viable population once more. In the 1970s and 1980s the then Nature Conservancy Council pioneered a re-introduction scheme using Scandinavian sea eagles and now, after an absence of nearly a hundred years, these birds are breeding successfully on the west coast of Scotland. The RSPB is currently running a similar re-introduction scheme for red kites, using both foreign and British birds to expand the range of the vulnerable Welsh survivors. Goshawks seem to have re-established themselves from escaped falconers' birds and continental colonists.

Despite these happy tales, however, British raptors remain difficult to get to grips with. Most are understandably very shy and will not tolerate close approaches; many are difficult to find away from their nests where both skill and permission are required to photograph them. For many of us the best chance of a close introduction to these birds is at a bird park.

often just as shy and easily frightened as their wild counterparts, so please respect any restraints on your access, such as barriers and bars. These are for the birds' benefit, not just to frustrate you.

The golden eagle (p. 25) is quite simply a stunning bird, and I had always wanted to take a portrait of it. However, to get close enough in the wilds of Scotland, where this shy and rigorously protected species tenaciously retains a talonhold, would be almost impossible for even the most accomplished professional. So it was back to the Hawk Conservancy to wave my lens at the one-winged and thus 'doomed to captivity' eagle that had shown no interest in breeding and, to the delight of thousands of visitors, whiles away its hours in a large open enclosure. The enclosure has a low fence at the sides and is dressed with elder, willow and cypress trees, none of which is typical eagle habitat. Consequently, after getting Ashley's agreement, I brought my own piece of Scotland with me.

I spent over an hour carefully tying and clamping an array of storm-damaged Scots pine boughs around the eagle's favourite perch. Making sure that the needles on the different branches aligned with each other, I placed a large dense spray low and in front of the perch and another one higher and behind it, leaving a pre-measured eagle-high space in the middle. This would allow me to focus on the subject and to frame the bird in a soft, grey-green surround of out-of-focus pine. To mask any telltale details behind my set I hung a large piece of green cloth over a beam. Next I set up my tripod and camera, checked exposures and noted how various depths of field affected the detail in the foliage. Lastly one of the staff carefully placed the eagle on his block and in less than five minutes I had my photograph. Thanks to the generosity of the Hawk Conservancy, all the hard work was in collecting and setting up the foliage. After all that, however, I don't really like it very much! I think it's a bit too tight on the head.

## A cuddly killer

THE PHOTOGRAPH OPPOSITE was taken at Weyhill and shows a peregrine falcon resting on its block in the mews. I photographed the bird for three hours and shot about twenty-five frames, and this is the one that worked best. Initially the bird was wet and continually preening itself, its spiky plumage sparkling in the sunshine. He never looked really content and continually shuffled around frowning and fidgeting, often sneering at me as if aware of his temporary disability. (Wet peregrines do not fly as well as dry ones; bathing is a necessary chore, not a treat, for one of these sickle-winged assassins.) As the hours passed, the sun became diffused and the bird began to doze. By repositioning myself to get an out-of-focus green background and by holding a fistful of grass immediately in front of my lens I was able to take this naturally green-filtered picture. The composition was straightforward, the bird's big black body merging into the denser green of my grass filter. All I had to do was wait for him to look over his shoulder at me and snap! There it was. There is no trace of captivity here. The photograph does not show his artificial perch or the leather jesses which prevent him from flying off when

**Peregrine falcon**
*Canon A-1, 70–210mm zoom lens, tripod with cable release, Kodachrome 64*

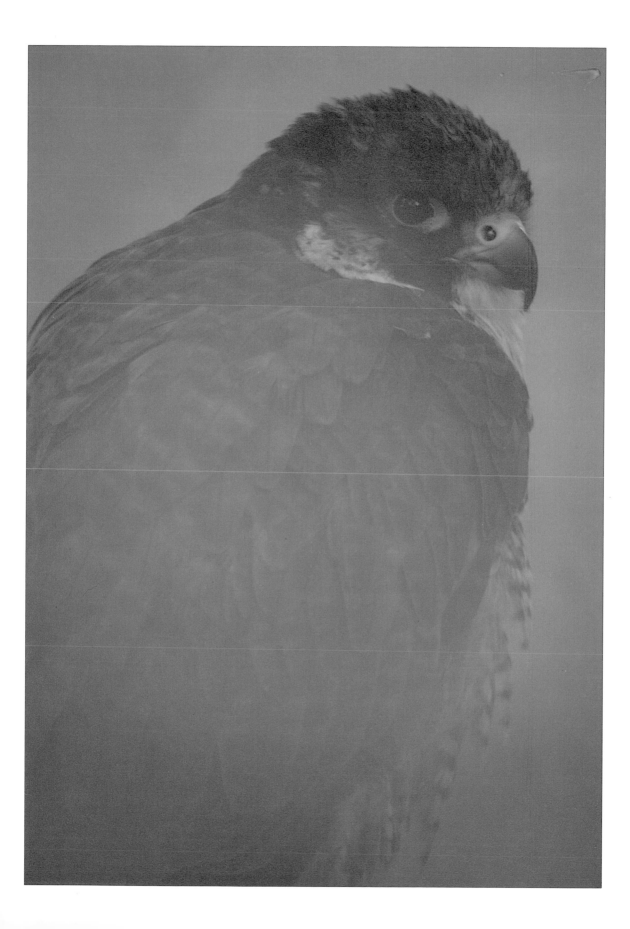

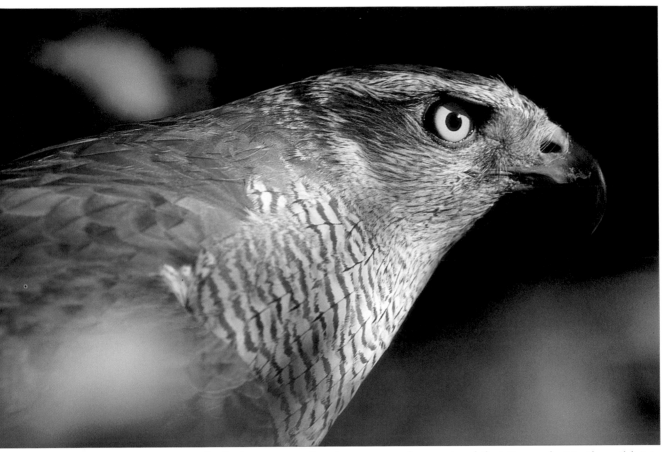

**Goshawk**
*Canon F-1N, 70–210mm zoom lens, tripod with cable release, Ektachrome 100 Professional*

he isn't meant to, but I see no need to pretend that it was shot in the wild. It is simply a nice portrait of a beautiful bird at rest. The highly strung killer has unloaded his urges and is sleeping in the shade.

## Fierce or fluffy

THE TWO PHOTOGRAPHS above were taken using exactly the same technique, only on a different scale and with different foliage.

Here is the most sleek, staring and dangerous winged weapon in Europe — a goshawk.

Found all over Europe, although restricted and sadly still persecuted in many parts of their range, including Britain, these animals are organic terminators. Fast, furious, stubborn beyond a million donkeys, insanely strong and cosmopolitan in their taste for prey, they are quite simply the tops in the killing stakes. Look at the flaming brimstone in those eyes, read the intent running down that elegant curve over the head to the top of that hard brutal beak and fear its temper. Goshawks require expert handling.

This female was 15 years old when I surrounded her with some oak sprigs and photographed her in the shade of Jim's garden. She didn't like me or my camera and spat hellfire before she finally settled long enough for this picture of her in prone, primed and primeval pose, snapped in a nano-second before

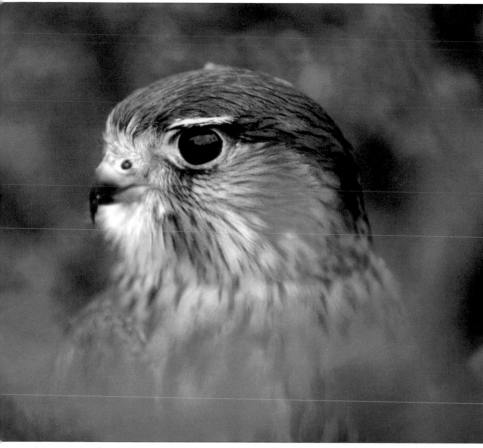

**Merlin**
*Canon F-1N, 70–210mm zoom lens, tripod with cable release, Ektachrome 100 Professional*

she sprang from her perch. Sadly she died last year, a tragic loss to her owner, but such was the strength of her presence for that hour I spent with her in 1989 that her naked power and predatory potential remain keen in my mind.

Merlins are our smallest falcons. They spend their summers breeding on the remaining fragments of moorland in Wales, the north of England and Scotland. Afforestation, unfortunately still popular in these areas, initially provides them with a rich habitat due to the temporary influx of their small bird prey. As the trees grow, however, the habitat becomes sterile and the merlins are probably forced to leave. Although they normally nest on the ground, they have recently been found nest-building in sitka spruce, so perhaps they are evolving to exploit this new resource and to remain in the forested areas. Nevertheless, they are a critically endangered British species. Merlins have been used for falconry for hundreds of years, most popularly for catching larks in the last century. Despite this they are fragile and difficult to keep so it was a real treat to be able to photograph this wonderful male, or jack, Merlin which belonged to another falconer friend, Jim Chick. A few sprigs of flowering ling (heather), held in clamps behind and in front of the bird, provide the 'naturalness' of the photograph, which was taken when the bird struck this curious frowning pose, his head well fluffed out and looking quite content.

# Simple Tricks

When I returned from the Camargue in September of 1983 with my two flamingo pictures (see pages 20–23), I realized that whilst I had a short life of experience of wildlife behind me I hadn't a clue about photography. I immediately devoured every textbook I could borrow or buy and enrolled in an evening class where I learnt the chemical and physical theories of film, all about lens construction, reciprocity failure and printing. More important, however, were the hours and hours I spent studying and analysing other photographers' work. With one exception — Franz Lanting — none of these were nature photographers. At that time wildlife photography really was in the boring old doldrums where it had been languishing since the 1940s and 50s — straightforward, pin-sharp, uncomposed, illustrative portraits taken by a clique of romantic snappers who relied on the antics of their subject or tales of their own suffering to enhance their photographs! Art was left to Ansel Adams, Ernst Haas, Cartier-Bresson, Franco Fontana, Bill Brandt, and a number of new-wave Japanese landscape photographers, whose work was little seen in Europe. So I studied these masters' works, particularly when they have turned their lenses towards natural subjects. It was so clear to me that gifted or great photographers had an eye for a picture, irrespective of subject, and when that subject was nature — kapow! (Find a shot entitled Great White Egret by the portraitist Bill Brandt, and you'll see what I mean.)

## BIRDS AND THE LAW

Every species of British bird is protected by law, which means that you have legal and moral obligations to respect their welfare at all times. The majority can be approached, even at their nests, without any threat of prosecution, but for me there is no difference between a level of irresponsibility that causes a pair of starlings to desert their nest and offspring and that which freaks a pair of rare birds such as ospreys.

Rare birds are classed as 'schedule one' species under the terms of the Wildlife and Countryside Act, and you must have a special licence to photograph them in the wild. Around 80 rare species come into this category. If you are found guilty of disturbing them, you could be fined as much as £2000 and lose any chance of ever being properly licensed in the future — a serious handicap for a budding bird photographer. You are liable to prosecution if you intentionally disturb such a species in the act of nest building, or on or near the nest when it has eggs or dependent young.

To acquire a licence to photograph such birds, you must first tackle a range of other species and prove your competence to English Nature, the body which administers licensing in England and Wales. Scotland has its own equivalent. You will have to prove a responsible moral attitude that ensures that you do not interfere with the activity or ecology of the birds, that you can keep nest sites secret, do not over-garden (throwing the nest sites open to the elements and predators) and that you can achieve your objective with the minimum of visits to the site. Good references are necessary for a successful application, as is more than a modicum of experience.

A brief but excellent leaflet entitled 'Bird Photography and the Law' is freely available from the RSPB, The Lodge, Sandy, Bedfordshire, England, SG19 2PL for an A5 s.a.e. Any further enquiries should be directed to the Licensing Section, English Nature, Northminster House, Peterborough, England, PE1 1UA (tel: 0733 340345).

I studied the way these artists used colour, texture, form, shape and the character of a subject to portray it; how they used composition to great effect, and how they reduced detail to produce a picture from nothing at all.

At the same time I also read lots of practical photography books which had some neat gimmicky ideas and, putting my precocious pretentions to art aside, I set out to replicate these gimmicks using nature as the subject; simple ideas about framing, filters, exposure and technique which people had used for ages, photographing everything but nature because that was too sacred. Not any more!

I have written this self-indulgent preamble because there is not really too much to say about the following six photographs. They illustrate three obvious techniques applied to birds. Firstly, multiple exposure.

## Fidgety puffin—a multiple exposure

ON THE ISLAND of Skomer, off the coast of south Wales, there is a site known as the High Cliff, where a few puffins have their burrows. First thing in the morning (you'll need to stay overnight on the island to be there in time) they line up here in the sunshine, whilst the cliff behind them remains in shadow, effectively black. With a brightly lit subject like this in the foreground, the photographic possibilities were obvious. What hampered the composition was the persistent head-turning of the puffin who was continuously on the look-out for predatory lesser or greater black-backed gulls. Flick, flick, flick; click, click, click — in fact five clicks in one frame of the same bird, in the

**Puffin**
*Canon A-1, 500mm mirror lens, bean bag, cable release, Ektachrome 200*

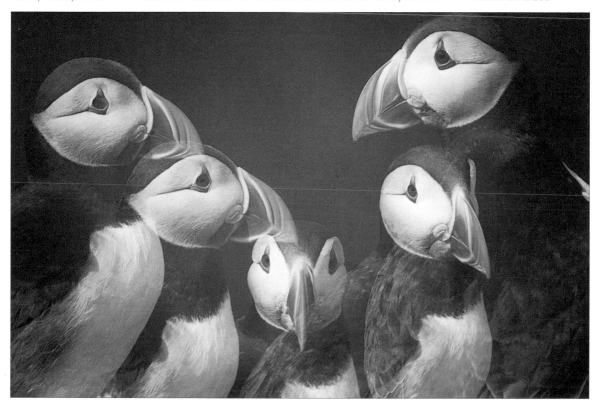

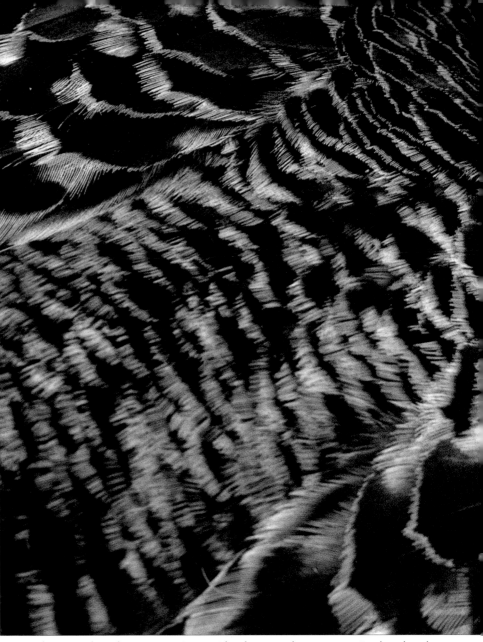

same place, within the same minute. I had wanted symmetry in the shot but this was the best I got, and also the best exposure, given the thumbnail calculations I made underexposing each separate exposure a little to account for ambient light fogging the frame. There seemed absolutely no point in even trying to replicate the thousands of perfect colour postcards people have taken of these endearing and photogenic little birds, so this was my 'nouveau' way out.

## Eider abstract

YEARS LATER I visited the Farne Islands off Seahouses in Northumbria and, in between mouthing marvellous tales about the migration of arctic terns for children's BBC, stole a few minutes to point my lens at point-blank range at this eider duck. Getting so close to a breeding bird is no problem on this

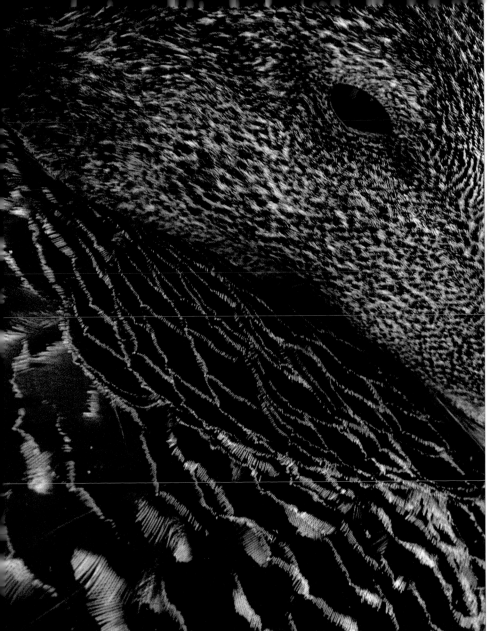

**Eider duck (detail)**
*Canon F-1N, 70–210mm
zoom lens,
tripod with cable
release, Ektachrome 200*

island; there are thousands of arctic terns nesting on the plateau, often laying their eggs only centimetres from the stringed-in walkways. So long as you stay on the path and remain sensitive to the fact that they are nesting, you are legally and morally free to do as you will. No stalking and no hides are necessary, although in June the tenacity of these ocean-wandering, screaming lunatics may make you wish you had a hide for protection. They have very sharp beaks and think nothing of sharpening them further on your scalp! That aside, it is a fabulous place to visit for a day, and with very little preparation you can get some stonkingly good close-ups of birds.

The eider duck is a remarkably cryptic bird which normally nests in piles of rotting seaweed between boulders on the upper beach. On Inner Farne the pathside will do, because there are no mammalian predators to hide from. So long as you are quiet, they will do no more than bat an eyelid as you crane

**Snow goose**
*Canon A-1, 500mm mirror lens, tripod with cable release, Kodachrome 64*

36

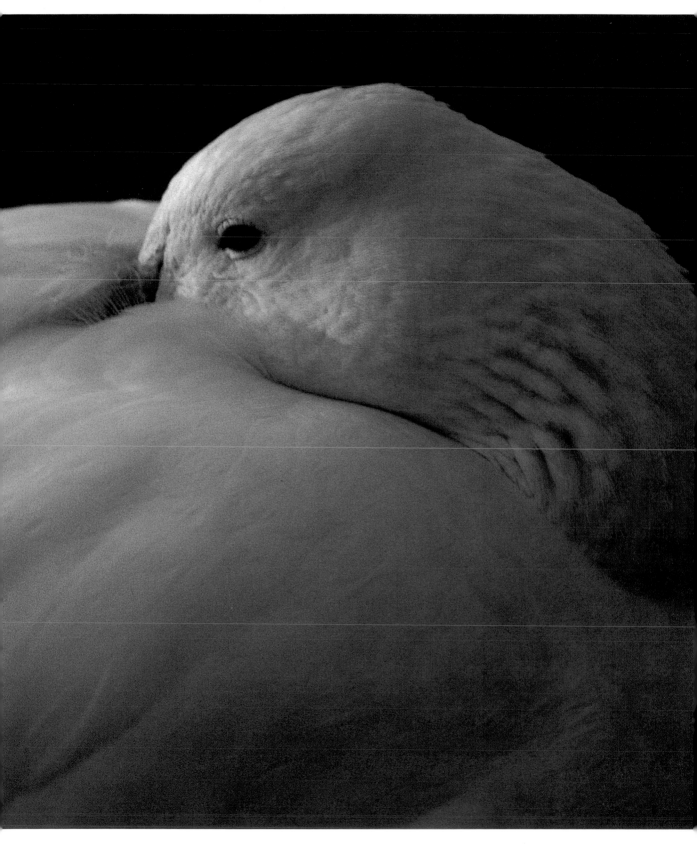

over them with your lens. Eiders are Britain's largest ducks and well known for their down, which once filled quilts and pillows worldwide. When the female makes her nest, she delicately plucks the down from her breast to cover and better insulate her often large clutch of eggs. This lining was pilfered daily by the 'slumberland' folk who in turn provided safe nesting islands for their precious birds — a seemingly symbiotic rather than exploitative relationship, which still continues on a reduced scale in Iceland.

The picture shows the back, neck, upper wings and back half of the bird's head. The tiny eye peers from the intricate splattering of fawn speckles over tawny and chocolate flecks. The bird can be identified, but the abstract view focuses on only one aspect of its form — its remarkable camouflage.

## Sleeping beauty

ABSTRACTS OF APPROACHABLE birds always appeal. The snow goose on the previous page was caught with the last frame of a roll of film as the last rays of a winter sun set over the Wildfowl and Wetland Trust's collection at Slimbridge. All day I had wandered about in frustration wasting snaps of ducks and geese in the freezing cold, and it was not until I took a last look around that I saw this sleeping beauty framed against the dark background of a willow hedge. I set up my camera and shot two frames too wide and with the bird's eye closed. I was just moving in closer when Mr and Mrs Riot and

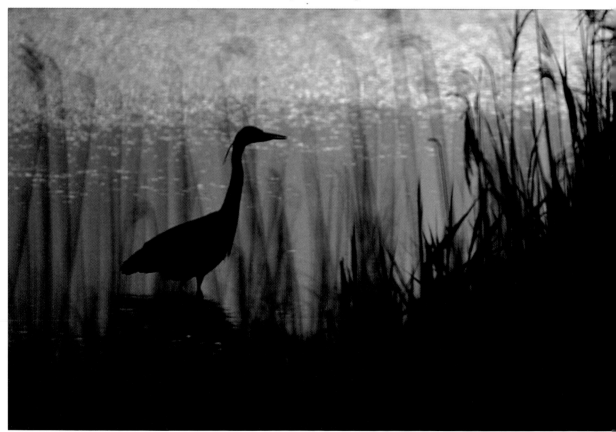

their children, Din, Raucous and Explosion, appeared at the end of the pen! The goose cracked its eye open, its two or three slumbermates made for the safety of their pool and with little time to compose and expose I shot this a second before the terrified gander fled and I ran out of film. So it was number 36 on about my third 'professional' film, and I cannot possibly relate the anguish I endured waiting for that little yellow packet of processed slides to rattle through my letterbox. It's still one of my favourites.

## Silhouette in the shallows

THERE IS NOT much to say about this opportunistic shot of a heron standing in the shallows of the RSPB's Titchwell Reserve in north Norfolk. I had slept in my car in the car park overnight. Car-park sleeping is not really good fun. You wake up feeling uncomfortable, cold, dirty and normally hungry; but how easy it is to open that door and step into the world compared to rolling out of a warm bed, having breakfast, cleaning your teeth and then driving miles to the site. Besides, at that time I couldn't afford B & B as well as Kodachrome 64! I saw a hundred dawns over the dashboard of a Renault 16 in 1984, and do not regret any one of them.

Normally I never consider cropping when shooting slide film — I have always regarded it as an extreme test of skill. You have a fixed frame in which to compose, expose and capture your ideal. Here, though, you see a severely

**Heron silhouette**
*Canon F-1N, 70–210mm zoom lens with ×2 extender, tripod with cable release, Kodachrome 64*

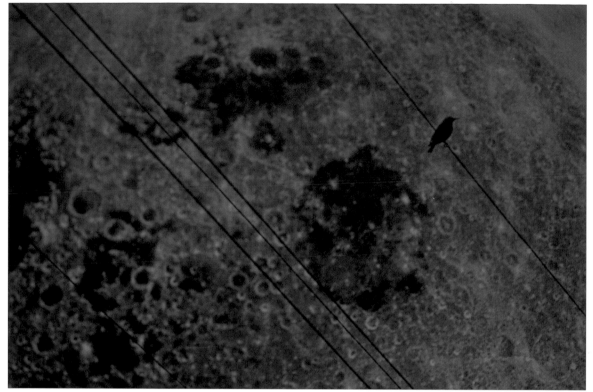

**Starling on the moon**
*Starling: Canon A-1,
500mm mirror lens,
tripod with cable release,
Kodachrome 64
Moon: Canon F-1,
100mm macro lens,
tripod with cable
release, 80B filter,
Ektachrome 100*

cropped image. The bird was small in the frame and both the top and bottom contained areas of uninteresting uniform tone. So why not cut it out — something to consider when you print your best efforts. I'm afraid it remains unremarkable to me, although I liked the colours.

## Starling sandwiches

USING A completely bland shot of a starling perched on some overhead telephone wires, taken at dusk on a freezing night at Welney Marsh, I produced both the images above.

I wanted to superimpose my five lines and starling onto the Sea of Tranquillity, so I bought an adapter to attach my camera to my 60× magnification bird-watching telescope. Using a tripod and support system that Heath Robinson left me in his will, I failed to get a shot, because using an aperture of f 128 I needed such a slow shutter speed that the moon moved during the exposure and blurred it. Undaunted, I dug out an old *National Geographic* magazine, found a nice contrasty black and white photograph and re-photographed part of it through a heavy blue correction filter. I am sure this probably contravened some copyright laws. I could probably be sued by NASA, but by sticking the result back to back, i.e. emulsion to emulsion, with my starling I got the photograph above. I think it's a really naff shot so I tried again.

Whilst walking the dog at dusk the next winter and watching black-headed gulls flying in formation down a local estuary, I sat staring at a row of

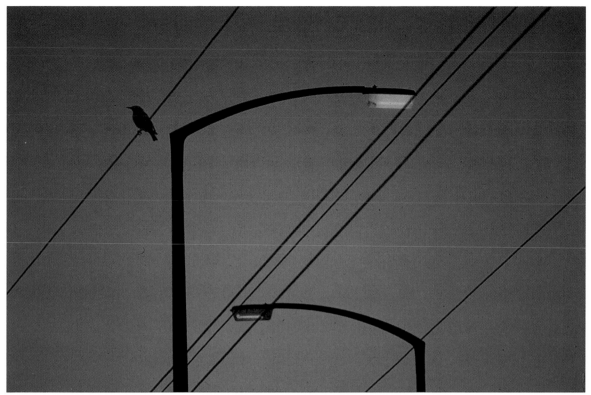

street lights and dreamed up a picture of one such light glowing against an orange sky capped with a row of five black-headed gulls in profile. Nice. I tried about five times on suitable evenings but the birds always left their perches about five minutes before the lights came on. Those from further upstream never felt tired enough to pause a while. I got cold, considered asking the Council to switch on five minutes early, and blew away two frames in desperation. When the processed slides arrived my starling sandwich flew into my mind and here is the result.

**Starling and streetlights**
*Canon A-1, 500mm mirror lens, tripod with cable release, Kodachrome 64*

## SANDWICHING SLIDES

IT IS A RELATIVELY EASY procedure to sandwich slides of two different images together to form a new composite image. You will need to bear in mind, however, that the projector light will then be shining through two film originals, so each one should be on the thin, overexposed side. Dark, underexposed images, or even normally exposed ones, sandwiched together may be too dense to be readable. If this is the case, you can try having thinner dupes made.

To preview the effects, place your slide images on top of each other and hold them up to a bright light source – a sunny window will do, but a light box is much better – and see how they work together. If you are satisfied with this, remove both originals carefully from their mounts, taking care not to scratch or mark them in any way, align them precisely together and place them in a new slide mount. You can also try orientating the slides in different ways if this helps the subject matter. For example, turning a slide over reverses the image left to right. If numbers, letters or words can be seen, however, these will appear as mirror images once the slide is 'flopped'.

# Freedom of Movement

ONLY WHEN A BIRD is on the wing does it fulfil its marvellous potential. Birds were made to fly; they are creatures of movement. See them on the ground hunting for food or on their nest and they seem awkward and out of their element – tense and wary, constantly alert for the least sign of threat or danger. Once airborne, however, they are free. Pure poetry in motion!

The images in this part of the book are my, sometimes successful, attempts to capture on film the grace and beauty of these wonderful feathered fancies. In my mind's eye birds are not clinically detailed, frozen portraits that proudly adorn the pages of so many wildlife books and magazines. Rather they are a momentarily glimpsed streak of colour, swirling masses of feathered frenzy lifting into the air, a rush of air past my face or a distant shriek.

## The form of flight

'PUFFIN IN MOVEMENT', is the object of the picture opposite, as opposed to 'Puffin spoiling picture through excessive movement'. Shot a couple of years after the multiple exposure picture on page 33, in exactly the same place, I have tried to convey the madcap rush of these birds as they hammer in from the sea to their nesting burrows. Stricken with fear, they home in on their cliff-top perches like missiles, running the gauntlet of predatory gulls. Even if they are not grabbed and killed, the little puffins are often so terrified by the gulls' dastardly pursuit that they drop all their hard-earned fish into the sea and therefore surrender them to the gulls. Puffin flight is furious. They have small, shallow and stiff little wings, which, coupled with their rotund bodies and big beaks, means they have to flap like the clappers in order to fly through the air — about 300 beats a minute! Flying through water, which is what they actually do once submerged, is not such a problem and puffins excel with a few quick flicks. Indeed it does seem that our northern auks, guillemots,

## PANNING

PANNING THE CAMERA is often the only way of recording the movement of a bird in flight. This involves moving the camera to keep pace with the subject so that it remains in approximately the same position on the film during the exposure. Obviously, all static parts of the scene will blur, but this can help throw your subject into relief and create a sense of depth and perspective. It's difficult to be too precise about which shutter speed to use – 1/30 or 1/15 second should give a recognizable image with some reasonably sharp subject detail of more static parts of the bird, while slower speeds will create increasingly impressionistic images containing virtually no sharply recorded information. If you have loaded the camera with particularly fast film and light levels are high, you may find that even with the smallest aperture you still can't achieve a sufficiently long shutter speed for panning. You could despair and give up or you could slip a neutral density filter on the lens. These are available in a range of different strengths and they cut down the amount of light reaching the film without affecting colour or contrast. Very useful accessories!

razorbills, puffins and so on are well on the evolutionary way to becoming 'penguins'. Nevertheless, in this millennium at least, they will continue to race to the safety of their holes at speeds which require an exposure of $^1/_{1000}$ second to even attempt to stop.

This picture was shot on an exposure of $^1/_8$–$^1/_2$ second. By panning with the bird I reduced its form to a shuddering shape so that it identifiable only by its bright bill and feet. This is the kind of view you get if a puffin surfs by you on the cliffside. My eyes do not register birds' wings frozen in motion. I see blurs, identifiable only by key features of recognition.

This technique is not new or clever. Ernst Haas took some remarkable slow-exposure pictures of bull fighters and horses in the 1960s and turned what many thought of as mistakes into real impressionist swirls of colour that conjured up a far more emotive response than rigid sharpness can often evoke. Franz Lanting produced a whole portfolio of beautiful blurred birds, often so distorted into swirling shapes that they are unidentifiable.

## Shapes of a swerving flock

THE PICTURE overleaf shows a skein of oystercatchers over Langstone Harbour in Hampshire. Like the puffin, their red legs and bills make them easy to recognize; but their boldly marked wings, with their deep stroke and overlapping cycles of flight, form a more sculptured blur. This photograph bears less resemblance to what the eye would normally see because such a confused picture only normally results if you are very close to the moving flock, and generally you are not in the middle of such activity, but watching through binoculars from some distance away. In this instance I was working

**Puffin in flight**
*Canon A-1, 500mm mirror lens, neutral density filter 2, Ektachrome 200*

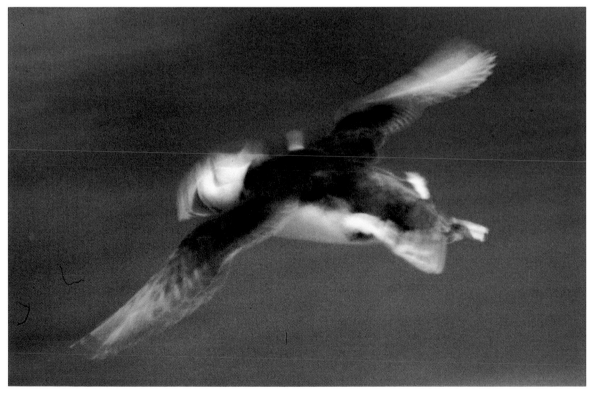

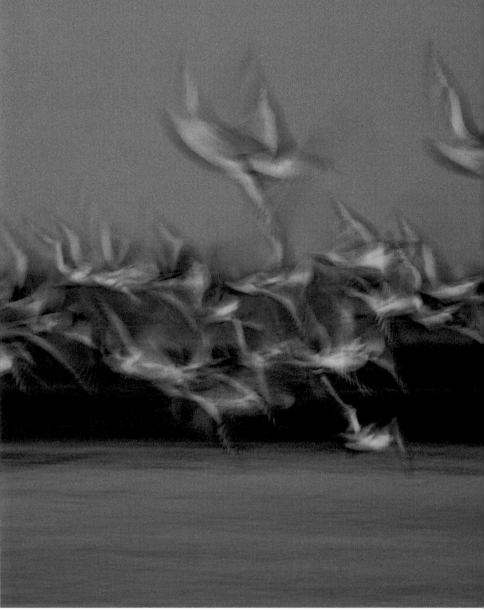

**Oystercatchers in flight**
*Canon F-1N, 70-210mm
zoom lens, tripod,
Ektachrome 200
Professional*

in a hide filming little terns under licence for the BBC. Whilst I got some boring family portraits of little terns at the nest, this was the shot I waited for.

As the tide came in it pushed more and more oystercatchers up their roost and onto the shore. Their numbers slowly rose and they became increasingly compacted on their favoured sliver of shingle. Eventually a few began to dribble away to their high-tide roost on the other side of the harbour. I pre-focused my camera, set it on an exposure time of ½ second, thereby giving myself an aperture with a healthy depth of field and, as the bulk of the birds took noisily into the air, blew away about six frames on my winder whilst panning with the flock. I think you either like or loathe this type of picture. I like it, I like the colours and the simplification of the birds' forms and the landscape. The reduction of unnecessary detail focuses attention more on the movement element of the picture than on the species, its environment and the raw, rigid mechanics of flight.

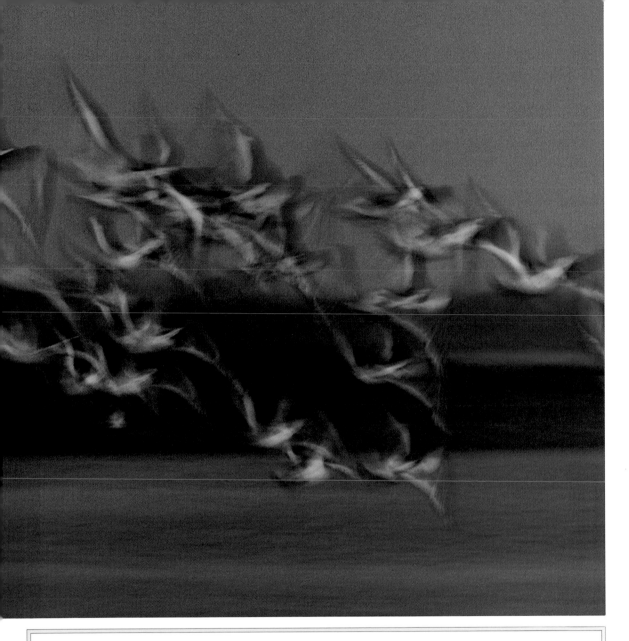

## FREEZING MOTION

I ACCEPT THE fact that many people prefer to gloat over miraculous, frozen-winged, pin-sharp flappers, perhaps because they are fascinated by what is invisible to the human eye but can be seized in the tiniest fraction of a second by a camera. Obviously relatively sophisticated cameras are necessary for this. To freeze fully the wingtips of a flapping bird, for example, you need shutter speeds in the region of $^1/_{2000}$—$^1/_{4000}$ second, options not available on all cameras nor often available in low light with fine-grain film and the less expensive slower lenses, which have relatively small maximum apertures. If you fancy shooting birds in flight you really need to invest in a specialist kit and I cannot recommend highly enough the new Canon EOS and its associated lenses. I tried them out recently on some swirling vultures with remarkable success, but I must remind all you frozen bird freaks that 'it is only with the heart that one can see rightly; what is essential is invisible to the eye' (*Antoine de Saint Exupéry, 1945*).

## Impressions in Snow and Sand

TO WAKE ON a winter's day and find the world transformed by snow is a treat not only for the snowman builder and snowball flinger but for the photographer as well. Snow simplifies any landscape by reducing the colours and smoothing over the details, it sculpts a less vulgar, more designed world where flat expanses of bright, white, even tone isolate gently curved reconstructions of everyday objects. Think of snow-capped trees and bushes, logs, fences, hills, dales and dells — even rusty old Volkswagens can be glamorized by a fair lick of snowflakes.

Sandscapes are very similar, yellow, coarse and unmelting but simplifying by nature. The wind-carved tops of dunes and their scalloped sides are, in low light, seen as no more than blocks of colour, tone and texture fixed beneath a sheltering sky.

If you enjoy minimalizing detail in your pictures, both sand and snow can prove invaluable. If you enjoy natural shapes and colours, both can yield abstract images with no subject at all — curved Mondrian-like scenes, patches of colour framed and composed by their edges.

## Snow sketch of a gull

I HAD BEEN looking at some Japanese photography books in which there were pictures of fragments of vegetation protruding from flat plains of snow. The photographer had used the snow to isolate his subject, to bi-sect it, but the texture in the properly exposed snow made it very three-dimensional, very tangible. I thought why not overexpose the snow, so the subject would be suspended in nothing but white space.

When snow arrived, I went out in search of possible shots. I took some shots of grass fronds, but they looked like brown scratches on the frame — too abstract for some. Yet anything with too much form, anything too identifiable, just looked weird and rather silly 'glued' onto bright white. On my way home I spotted a party of coots wandering about on the snow-covered ice of a frozen pond. Immediately the image of ink-spots on clean

## PHOTOGRAPHING SNOW

PHOTOGRAPHING SNOW is not at all easy. All modern through-the-lens (TTL) metering cameras, as well as separate hand-held light meters, tend to see the highly reflective white of a snowy landscape as a vast area of intense highlight. Thus, they overestimate. In order to fulfil its programming and render mid-grey tones readable on the finished print or slide, the meter tricks you into underexposing the scene. Muddy grey landscapes are the inevitable result. To overcome this type of problem you will need to experiment with your camera (use a notebook to detail your exposure settings and check these against your results). As a general rule-of-thumb guideline, I have found that I need approximately two and a half stops over the meter reading to achieve the correct exposure to bring out the whiteness of snow, but this varies according to conditions. If your camera is of the 'I know better, fully automated variety' that won't allow you to override the meter, all I can suggest is changing the ISO film speed setting to fool the camera into believing it is loaded with slower film. This will cause it to open up to compensate. Halving the ISO will give one stop extra exposure.

white paper came into my mind, so I leapt from the car and shot about ten frames. But the coots proved to be too black, too gangly; moreover, they were on disturbed snow which was difficult to white out completely because of the shadows in its ridges.

I was feeling quite inadequate when I saw three black-headed gulls fly in and land well away from the marauding coots on some fresh snow. Again I immediately knew what I wanted: a white frame with red legs, red beak, black eye and eye spots and black wing tips. No body, no detail, just a few shapes of colour making a form out of nothing. The trouble was I had one frame left, no spare rolls, and two of the gulls had already gone.

Here, I knew I needed to overexpose more in order to get the snow truly white but had no room to gamble. I put the bird in the top left-hand corner of the viewfinder, screwed on my cable release, and 'did the biz' at 5 stops over what the meter indicated.

I've never run out of film since. I agonized all night over my failure to be 100 per cent sure of getting the picture I had been thinking about for months and looking for all day. The bird had flown off almost immediately anyway, so I would probably not have had the chance to re-load, but that was not the point. My incompetence punished me severely. Still, as it turned out I had guessed right and got the picture below.

**Black-headed gull on snow**
*Canon A-1, 500mm mirror lens, tripod with cable release, Kodachrome 64*

**Oystercatcher on snow**
*Canon A-1, 500mm
mirror lens,
Kodachrome 64*

# Cold snap

A SIBERIAN-STYLE winter snap had so stunned this oystercatcher that it was
frozen enough to stalk until I was probably no more than ten metres away —
a rare treat with these striking waders, which are normally quite wary. I say 'a
rare treat' with my tongue firmly in my cheek, because crawling on my
sodden belly over a frozen field, with my collar acting as a snow scoop for
what I later realised to be three-quarters of an hour, is not really a treat at all
— especially when the very necessary act of breathing out would produce
great white puffs of steam which could disturb my subject. I was not even
sure my blue fingers would work when I got there.

I wanted to use a small scoop of snow just in front of my lens to fog the
bottom of the frame and reduce the bird to a black blob with a red beak.
Surprisingly, I was able to move closer and closer until I could almost fill the
frame with one of the five or so birds in the loose flock. I made my snow
'filter' and, as the birds defrosted and dozily realized they had been joined by
a refugee from the Russian Front, I shot three frames, using my winder, before
they raked away into the wasteland in the space of about two seconds!

Of the three this is the most compact composition, but the photograph
suffers from the background not being completely bleached out. (This is a
result of the previously explained problem with TTL metering.) Blueness is also
a curse: the sky is reflected in each snow flake's shard and washes your
whiteness away. Overexposure is necessary to combat this additional
problem, and the success of this depends on the non-snow subject. With

black birds you are quite obviously safe, because there is a fair bit of light to add before they burn out, but gulls and other paler forms need caution. In this instance, of course, there was no time for bracketing; but I would always waste a few frames on this safety measure if I had the chance.

## Desert delights

I LIKE DESERTS: the heat, the simplicity of a landscape of just sand and sky, and the way that the wind whips up those beautiful curves, crests and ridges, all appeal. Sadly, deserts are few and far between in the UK — but we do have a few remnants of sand dune systems and the marvellous shingle wastes of Dungeness. Even at the end of the war there were large inland areas of shifting sand, notably in the brecklands of East Anglia. Now these have been afforested and our remaining sandscapes are all coastal. Newborough Warren on Anglesea is superb, there are some dunes near Banburgh Castle in the North-East, even fewer at Studland in Dorset, a remarkable system at Culbin Sands near Inverness, more at Braunton Burrows in Devon, but perhaps the best collection is at Holme in north Norfolk. It was here, on a bright sunny afternoon in a stiff breeze, that I photographed the stoic oystercatcher pictured overleaf on her eggs.

In many books and magazines on photography, you will be warned that sand is possibly the greatest evil known to your camera. Shutters shiver, lenses weep and tripods become animate and flee this substance from photographic hell. Special pouches, plastic packets for desert work, or polythene bags and elastic bands for occasional beachwear are all recommended. I ignored all of this, of course, and to this day three of my lenses — yes, even two that were safely packed away — screech at me when I twist them into focus. I wince as another little piece of crystal cuts yet another hidden scratch into the barrel. Sand is hard, sand is sharp and sand lasts for ever!

When we arrived on the dunes, it was obvious to my girlfriend that without camels, blankets, some Bedouin help and a few plastic camera pouches the day was lost. Such inadequacies never manifest themselves to me so I wandered out to be blasted alone.

After scouring around for some time in search of a subject, I came up with the idea of using wind-blown stone mist as a curtain to create an impressionist scene in which the flickering grasses became blurs of green in a dusty smudge of yellow. All I needed now was something striking that would stand out of the background and produce a point of focus in the haze. As I sat on the side of a dune, having my face scraped, my subject just wandered in, piped a couple of times and, in a desperate hurry before they were buried, settled to incubate its eggs. I slid down the slope, rolled onto my belly and 'commando'd' to within about 30 metres. Then, avoiding a crisp packet in the bottom of my frame, I shot about 6 or 7 pictures in various degrees of a sandstorm. When I returned, one side of my face was raw pink, I had sand in every orifice — yes, *every* orifice! — and worse, my trusty lenses were scarred for life! But who cares? I got the shot I wanted!

**Oystercatcher
incubating eggs**
*Canon F-1, 500mm
mirror lens,
Kodachrome 64*

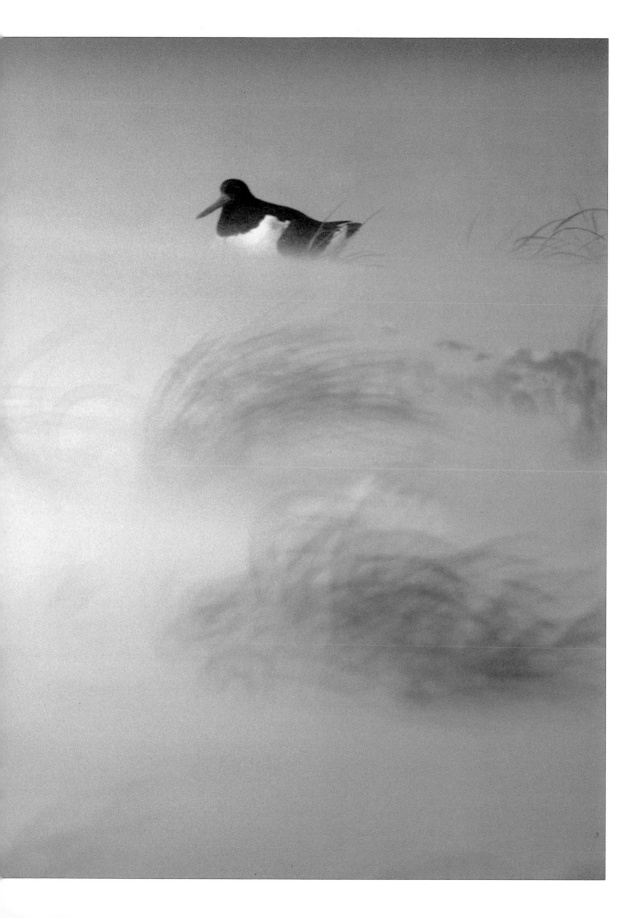

# Three Tawnies

TAWNY OWLS are by far the commonest of the six British owl species and can be heard, if not seen, over most of the British Isles except Ireland. The reason they have never colonized here is a bit of an ornithological mystery. They normally feed on a diet of small mammals, but hard times will force them to eat frogs, beetles and, during periods of prolonged rain, earthworms. Those that breed in the parks and gardens of our city centres further diversify their menus to include more small birds, such as sparrows, starlings and finches. To encounter the species, listen on clear, still nights in January and February. Since the birds begin breeding in March, their territories are established early in the year by audible contests of repeated 't'wit t'wooing'. In towns, rooftops and window ledges provide suitable platforms for such gigs, but ideally tawnies are a woodland species and any local plantations should be well worth a listen.

The rich earthy hues of the tawny owl blend in superbly with tree bark, a crypsis probably stimulated by a desire to remain invisible by day. In mainland Europe, where the larger eagle owl occurs, tawny owls are fairly frequently preyed upon by this species, but probably caught at night, so it must be the irritating attention given to tawnies by smaller songbirds, tits and warblers that has evolutionarily enhanced this camouflage so well. This mobbing by small birds is an anti-predator strategy that is designed to draw attention to any potential threat. However, spending nearly all day being 'serenaded' by raucous blackbirds, robins and great tits cannot be much fun, or conducive to a necessary rest period. Anyway, ignoring the mechanics of nature, tawny owls are highly attractive birds and make ideal subjects for photography.

**Tawny owl by day**
*Canon F-1N, 100mm macro lens, tripod with cable release, Ektachrome 100 Professional*

## Big close-up

THE PORTRAIT on the left, taken at the Hawk Conservancy, is awful. For some reason I put the owl in sunshine. Why? Nocturnal hunters don't generally like sunshine, nor do they look good in it. The bird's eyes have become black holes due to the excessive contrast and its subtle plumage rendered crude and gawdy by the brilliance of the lighting. I suspect I was interested in maximum depth of field, but as I was using 100 ISO film and a tripod I don't know what I was up to. Owls also tend to freeze in poses and then you can use a shutter speed of ¼ or even ½ second and never have trouble with a ¹⁄₁₅ or ¹⁄₃₀. Surely this would have given me enough depth

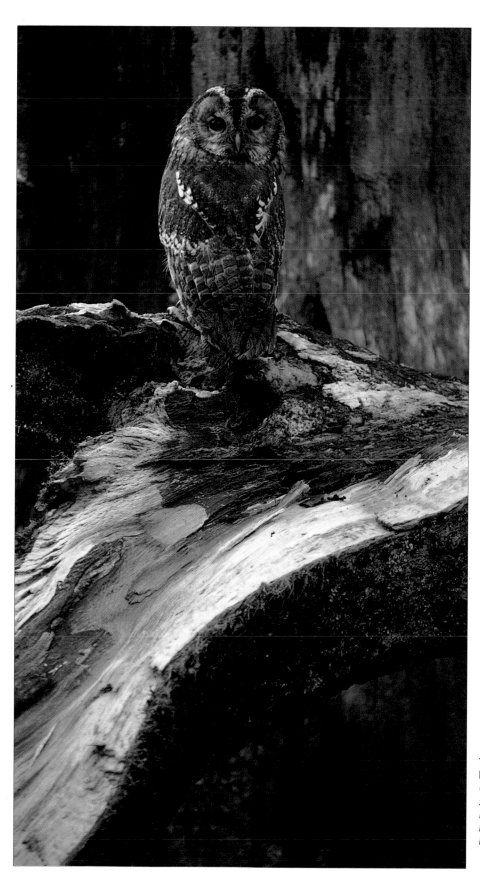

**Tawny owl on
beech trunk**
*Canon F-1N, 70–210mm
zoom with 2× matched
multiplier, beanbag,
Ektachrome 200
Professional*

of field to keep all the face sharp, lighting the bird through my diffuser to avoid harsh sunlight. Even shooting with the bird in the shade would have caused no problems and would have been a far more natural setting. I also failed to crop out all the background because of the shape of the bird's head. Altogether I feel it is a nasty photograph, serving only to illustrate the comparative success of the following two.

## Colour of woodland

THE PICTURE on the previous page of a young tawny perched on a storm-damaged beech trunk is far more satisfying. In the soft light of an autumn afternoon the colours of the owl are all repeated in the great sweeps of torn timber, yet the bird is framed against green and thus remains prominent on its sculptural perch. It stares straight at you, re-emphasizing the strong symmetry of its rounded face. The eyes are really the only animate feature in the photograph; the rest is just a tangled palette of woody browns. Here is an animal blending aesthetically into its natural environment: no bright foliage greens, no sky, no leaves, just bark, wood and algae. You can almost smell the musk of decay. The soft light and good depth of field have flattened the photograph and enhanced its abstract nature, and the creamy crescent of cracked beech trunk leads you up to the bird.

Taken in the New Forest in October this young tawny, probably suffering a little having been driven from its parents' territory, perhaps hungry and tired after the first few hard days of autumn, was dozy enough to allow me to approach to within 20 metres. I had seen him flopping around the clearing from some distance away and spent about ten minutes sneaking up, finally resting my camera on a bean bag flopped onto another crumpled tree. I got some ten frames off before I pushed my luck and tried to move closer. He limped away in silence through the dying year, and to be honest I don't think he saw many more days of it himself. The essential survival of the fittest is sometimes sad.

## Feathered fossil

FOSSILS, THEIR FORM and texture have always had a fascination for me. Have you ever looked at a trilobite or ammonite and thought that some gifted Victorian wag might have made it? Some are so perfectly preserved that they look sculpted, and the very idea of anything living being turned to stone is straight out of Grimms Fairy Tales! As a child I loved to handle them, rub them until they were warm and explore every curve of their ancient shapes. Dinosaur bones are OK but they are always large, chipped and cracked, like bits of burned wood pulled from the wreck of a bonfire. No, it's little fossils that are aesthetically appealing, and one of the most attractive of all is that contentious slab of limestone marked with the impression of the first bird, *Archaeopteryx*. In recent years it has been branded a fake, too obvious a missing link, made from chalky paste and chicken feathers by a Bavarian blackguard. I wished it had been proved; indeed, I revisited the Natural History Museum to examine their specimens and concluded that I could

**'Fossilized' tawny owl**
*Canon F-1N, 50mm lens, tripod with cable release, white card reflector, Kodachrome 64*

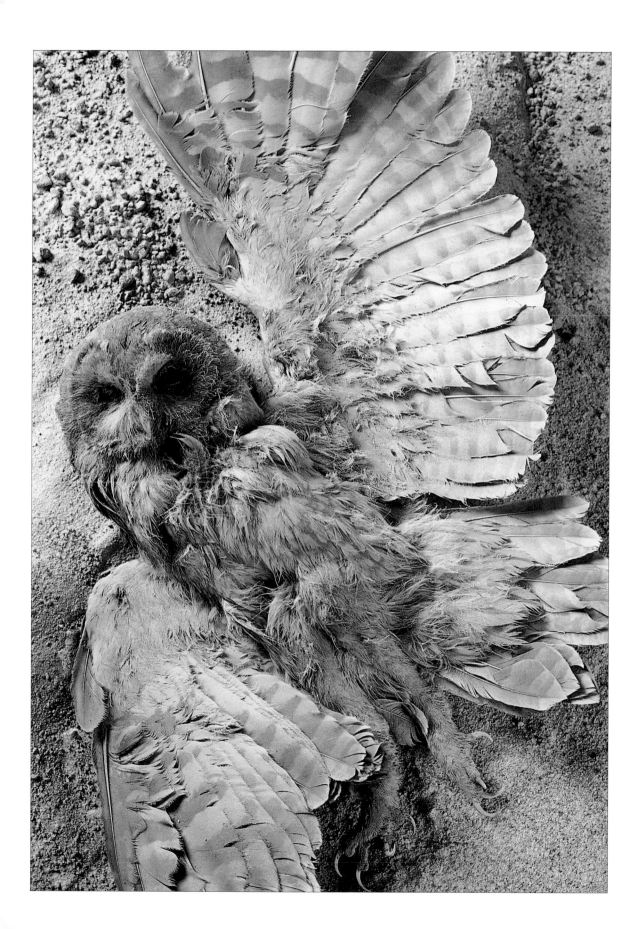

make my own without too much effort. A few months later, the unfortunate tawny owl on the previous page saved me the trouble.

In early autumn young tawnies are driven from their parents' territories to try and survive the first winter. The older birds know that harder times are coming and food will be in short supply, and they want to avoid any competition, even from their own offspring. Thousands of these displaced, inexperienced owls die. Hundreds get hit by cars and many more starve, as this poor individual probably did before it tumbled to the bottom of a cement silo and began to be 'fossilized' by the fine, grey, choking dust. I didn't discover this bird. Another photographer told me about it, and it sounded so good that I sped across town next day. I found the corpse kicked into a corner and did nothing more than move it to a fresh, unfootprinted part of the floor near the door. Setting my camera directly above it, I reflected some light back into the shadows by leaning a piece of white card against my camera case. It was bright outside but not sunny, so the light was nice and soft. Rembering the lesson I had learnt from the golden fish head in the introduction (see page 00), I stopped right down to get maximum depth of field and flatten the picture as much as possible. I was very pleased with my modern 'fossil'. It saved all that messing about with plaster of Paris!

**Black-headed gull in early morning mist**
*Canon A-1, 500mm mirror lens, tripod with cable release, Kodachrome 64*

# Reflections

REFLECTIONS HAVE always been a particularly favourite topic of mine. This simple shot of a black-headed gull on what appears to be a shallow shelf of a muddy

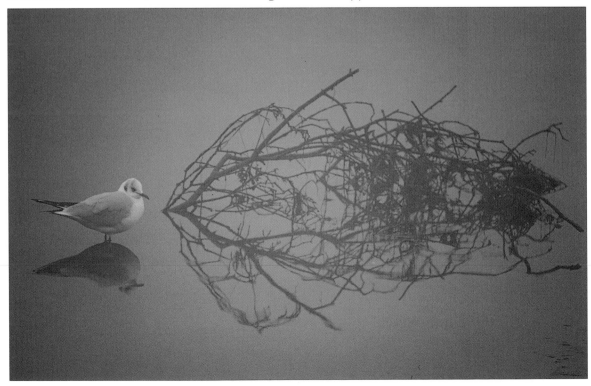

estuary was actually taken just after first light on a misty morning in a park in the heart of Southampton. I liked the way the reflected twigs and branches made a sort of symmetrical ink-blot image, the sort of thing I was encouraged to do by my less-than-ambitious infant school art teacher. As I took a couple of photos, the winter-plumaged bird walked into the frame, the subtle greys of the misty scene complementing its plumage. The photograph could almost be in black and white, yet it retains a cool, blue-grey aura. It is spoilt only by some detail of mud left by the fast retreating water in the bottom right-hand corner. The next and far more successful photograph overleaf was not quite as opportunistic as this one!

## Wheel of fortune

MOST CHILDREN'S BICYCLES are now fitted with colourful injection-moulded plastic wheels with only three or five spokes. How unattractive these will look when they appear in muddy dumps across the world. They lack the Spirit of Bicycle, and they will never discolour and rust. The photographers of tomorrow will be starved of the pleasure of wading knee-deep through stinking effluent only to find that their artistic bird perch has decayed beyond hope or to have a filthy wrestling match with another masterpiece which is so corroded to the remainder of the machine that even shaving one's knuckles will not prize it free. They will miss the elation of finding a perfect specimen in a dry ditch and the joy of its easy release at the jaws of an adjustable spanner.

Having spotted the photographic potential of a wheel and its spidery reflection in a local dump — a wheel which, despite great effort, refused to accompany me home — it was not difficult to find more and eventually the specimen you see illustrated on page 61. I liked the pattern, the figure-of-eight outling the multi-legged spider it contained. The reflection made an everyday object unusual and impractical, an artistic sculpture.

The subject would have to be a bird (insects were too small, flowers too easy) and it would have to be a waterbird to be of any relevance. The cracked sapphire of a kingfisher's back making shapes on the surface of a liquid jade pool sent a shiver down my spine and guided my crusade.

These elusive stickleback-bashers had always nested on a local stretch of a private salmon fishing estate, so I knew exactly where to go. I knew that outside the breeding season the shot would be impossible as the birds would have too wide a range and be too unpredictable in their perching. A burrowful of hungry young would keep them in the same place, however, so I waited until the tell-tale dribble of white guano began to drip from their hole in the sandy bank over the river (a sign of large young being present). Then I began to organize their lives a little.

Kingfishers are predictable birds. Having caught a fish, they return to a perch and beat it senseless before swallowing it. They also have regular perches near the nest on which they alight to align the meal correctly for their ravenous youngsters. Knowing this, I waded in about 25 metres downstream of their nest and laboriously erected my wheel at the correct

**Overleaf: Mute swan's feather**
*Canon F-1, 100mm macro lens with 50mm extension tube, tripod with cable release, Kodachrome 64*

**Reflection of kingfisher on bicycle wheel**
*Canon F-1N, 400mm lens, tripod with cable release, Ektachrome 200 Professional*

height so that a curtain of foliage on the opposite bank would provide a nice dark green background. Next I set up a hide. It was soon apparent that the kingfishers were not about to forsake their favourite perches for my monstrosity. In the few short days before the young fledged and dispersed, some radical action was needed. In this sort of situation, always try to keep choices to a minimum to avoid dissatisfaction. You know the idea — if you buy a packet of yellow sweets, no one can cry when all the red ones have gone! I tied back all three of the birds' favourite resting points with string and this left them just one choice — my wheel. The ploy was a success. The kingfishers had seen the wheel every day for about ten days and were used to my hide. Within two hours I had my shot and, with a quick snip, I released their original perches. Two weeks later I removed the wheel with a grappling hook, getting wet and muddy in the process, while the birds tended three young in an alder tree on an adjacent tributary.

# GETTING CLOSE TO BIRDS WITHOUT SPECIAL PERMISSION

A REAL TREAT for the novice bird photographer is getting really close, preferably without hides, to birds that cannot be easily perturbed by your behaviour. Rare birds cannot be photographed in the wild without a special licence (see page 00), but there are still plenty of opportunities around. Top of the pops are seabird colonies. Perched on precipitous ledges, these avians know you cannot easily predate them and thus gannets, guillemots, razorbills, a host of gulls and everyone's favourite — puffins — can be easily and safely approached. Skomer and Grassholm off Pembrokeshire, The Farne Islands off Northumberland, the Bass Rock off Berwick and Handa Island off Scourie on the northwest coast of Scotland are all in turn photographic favourites. All are managed nature reserves and it is absolutely imperative that you stick to the marked paths.

*Using a hide* Few other birds will allow you to approach closely, and using a hide is often your best option. There are really two types of hide to consider — permanent structures at nature reserves, and those which you buy or build yourself for particular shots.

Public hides are generally designed to give the widest possible view over a part of a reserve so that the maximum number of species can be seen. They are nearly always designed for bird watchers rather than bird photographers; the right angles and perspective for stunning shots rarely enter the constructor's mind. Nevertheless, you can get some fine photographic opportunities from many quiet public hides — especially if you are able to do a recce in advance and visit the reserve on a week day when things will generally be a lot quieter. At Minsmere RSPB reserve in Suffolk you can legally photograph avocets on their nests from public hides; and at Weeting Heath I've snapped the extraordinary stone curlew for a minimal entrance fee. The Wildfowl and Wetlands Trust has many excellent hides, too, especially at Martin Mere and Welney. At Welney there is even a centrally heated lounge with night lights.

When it comes to using your own hide, you have to take on a different level of responsibility. Make sure you obtain the landowner's permission and any necessary photographic licences before you erect your hide. Small portable hides are available commercially — check the classified ads in birding and photographic magazines. These are handy starting packages, but they nearly always have to be modified to suit your needs. Extra holes and snoots need to be made, and various features regularly need reinforcement for serious use.

Many photographers prefer to be at their subject's level and thus turn to sturdy one-man tents. These are low, light and portable.

Lastly there are natural materials and your own ingenuity — wind-blown branches, logs and boulders can all serve as a temporary hide.

I had achieved exactly what I set out to do, and I am very proud to say that not a single shot exists with the actual kingfisher included. I was not even tempted to raise my lens and snap the obvious, not even to make the figure-of-eight symmetrical, such was my reflective resolve.

## Sharp shooter

THIS IS my Clint Eastwood picture and it was taken using just the kind of manic reactions usually associated with gunslingers who shoot from the hip.

By the first couple of weeks in May, bluebells carpet woodlands countrywide. Their springtime fury is a result of their physiology. Being a bulbed plant — that is, a species that stores 'energy' to overwinter and flower the following spring — they need to produce all their leaves, reap the photosynthetic rewards, translocate their sugar product to the bulb and

**Jay in bluebell wood**
*Canon A-1, 28mm lens, autowinder, blue correction filter, Ektachrome 200*

flower before the woodland canopy closes above them and plunges the floor into sterile darkness. As soon as the frosts subside the race is on. Dog's mercury, ramsons, Solomon's seal and bluebells suddenly sprout and bloom. Only a few weeks later the hazel and oak sprout their own leaves, shade results and the pioneers wither and wait another year. The reason I have protracted the botany in a chapter on birds is simply that I was snapping bluebells and had just upped all my equipment to move on when I saw this jay fly out of the woods. My hand found the camera hung at waist level and I shot three frames on the winder. The clearing wasn't big enough for the both of us, so the jay left and so did I, bragging to myself that I had lightning reactions but honestly not expecting any success. Imagine my elation to find not only the bird in the frame, but a properly exposed, fairly sharp image and, when cropped slightly, an acceptable composition.

# REPTILES AND AMPHIBIANS

L IFE FOR school children must have been far less interesting before 1824 when William Buckland described the lower jaw and other fossilized bones of a giant reptile as *Megalosaurus bucklandi* — dinosaurs were reborn! Surely the most exciting animals yet to inhabit the earth, these distant giants dominated our planet's fauna for two hundred and fifty million years in the remarkable guises of Brontosaurus, Stegosaurus, Tyranosaurus, Triceratops and thousands of others well known to child dinophiles worldwide. Conan Doyle and Michael Crichton are not alone in the fantasy of a meeting between dinosaur and modern man. Imagine having two rolls of Kodachrome to expose in the Jurrassic, Triassic and Cretaceous periods!

Outside the realm of science fiction we are left with just over 5000 species of reptiles and half as many extant amphibians. Giant esturine crocodiles at around 6.5 metres long and 600–800 kilograms in weight and Chinese giant salamanders, which are 1.75 metres long and weigh 45 kilograms, are the only real giants but the remainder of these classes include some of the world's most exciting animals. The carnivory of crocodiles, the venom of cobras, rattlesnakes, mambas and vipers, the monstrosity of monitors like the infamous Komodo dragon, the great age of giant tortoises and the legends of giant boas and pythons, hold a deep fascination for herpetologists, authors, film makers and pub trivia quizzers alike. But sadly, or gladly for some, all the aforementioned species are exotics.

Britain is unfortunately starved of a rich diversity of reptiles and amphibians, but those that we have are certainly amongst our most photographic subjects. There are three indigenous species of snakes — adders, grass snakes and smooth snakes. There are common toads and frogs familiar to us all, marsh edible and pool frogs and one very localized colony of tree frogs. The rare natterjack toad, three newts (including the awesome great crested), the sand and common lizard and the slowworm make up the remainder of the British reptiles and amphibians. Some are very common and easy to keep, three are specially protected and cannot be kept or handled without a licence. Respect this law and ensure that all animals in your care get the attention they require. If in doubt, consult one of the many books or ask an expert — and remember that the well-being of your subject is always more important than your photograph. *Rulus inflexibilis*!

**Grass snake on bonnet of abandoned Morris Minor**
*Canon F-1N, 100mm macro lens, tripod with cable release, Ektachrome 100 Professional*

64

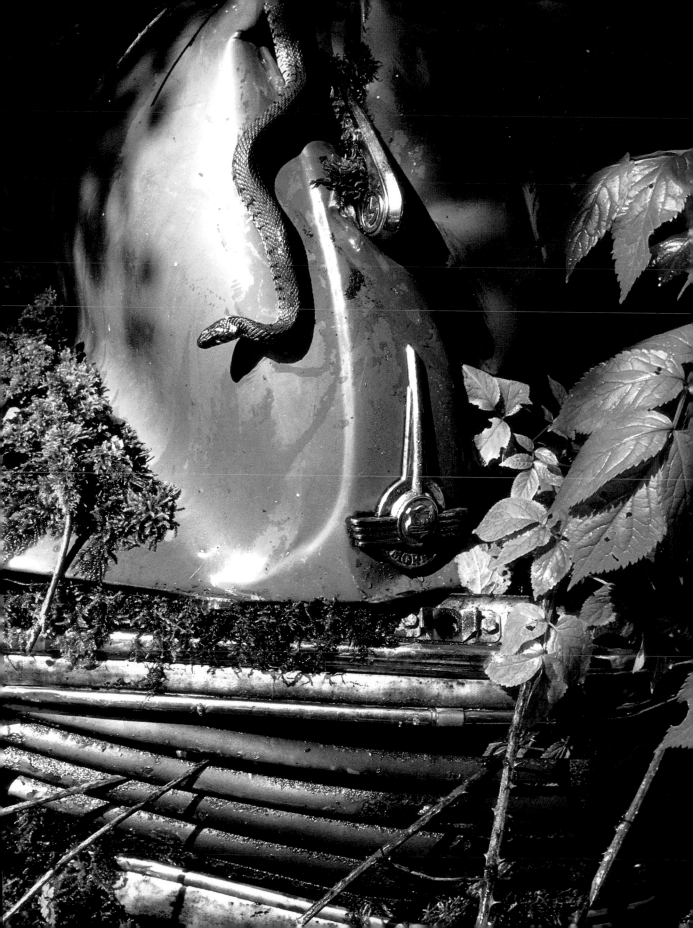

Reptiles are mostly shy animals which nevertheless can be photographed in the wild using a little field craft and some patience. If you wish to include a more artistic aspect in your pictures, however, then the untidy undergrowth in which they slither and scuttle is unlikely to take your fancy; and because there is no chance of reaching in and moving that frond of grass that is obscuring your subject's head, you may find it easier to use captive animals to produce controlled, pre-planned portraits. Here are a few.

# Snake Portraits

SNAKES HAVE wriggled and slithered into every corner of our culture, their perfectly enamelled scaly bodies have wrapped around our beliefs, art, music and writings. Sadly they have constricted or poisoned more than they have enlightened and as a consequence they engender an almost universal human fear. But fear breeds fascination — how I pleaded with my zoo-going parents to leave me all day in the musty reptile house to stare at fat, static pythons and fabulous vipers who returned my gaze from dangerous split pupils. By the age of 11, my bedroom was lined with tanks housing iguanas, skinks, geckos and snakes — wonderful snakes. In a few years I graduated from harmless North American garter snakes to deadly rattlesnakes. I've been bitten twice by venomous friends and the second time nearly slipped into a coma due to hospital malpractice. Waking up two days later coloured yellow, dripping sweat and wired to bleeps, screens and alarms is no fun, but my obsession with snakes continues unabated. On a recent trip to South Africa I was depressed to discover that one of my most sought-after quarries, the insanely aggressive black mamba, had already hibernated. These animals are mad, bad and dangerous — a bite would be fatal without serum, a luxury I can no longer afford as I have developed a fatal allergy to it. Thus an encounter would be interesting — I intend to return!

As usual, exotic species sparkle but for me they cannot outshine the three homeboys from Britain's bogs, grasslands and heaths. They remain firm favourites and a real test for my photographic skills.

## Two old favourites

AGONY, EXPENSE and energy — not necessarily in that order — were needed to achieve the shot of a grass snake on the previous page descending the overgrown bonnet of a wrecked Morris Minor after an early morning shower. In a way, this picture took three years to take. I'll explain why . . .

Out collecting badger faeces (for scientific analysis) in a remote, private wood, I came across three old cars that had been dragged there and dumped. Very untidy, yet these rusting hulks, hidden under a tangle of elder and bramble and overgrown with moss, had a nostalgic charm that reminded me of creeper-clad temples lost in the jungles of Burma. I thought about a photo — but there was no light, the cars had been used for a stock-car racing and were crudely painted, and I was short of a wildlife subject. Nevertheless I retained the idea . . .

Grass snakes are one of my favourite animals. They remind me of hot, sunny childhood summers chasing up and down verdant stream banks, lunging and lusting after their perfect plasticized bodies. They are so English to me, so 'watermeadows and musty ponds'. I love them! When I became seriously interested in photography I shot one in a tray of duckweed for a simple mosaic background (another story, another lot of trouble), but I wasn't happy. Then I remembered those old cars, and the wheels went into motion!

I visited three scrapyards looking for old English cars with character, preferably ones that were olive green. I virtually lit up when I discovered this old Morris and was elated to pay the then princely sum of £15 for the battered bonnet and rusty grill. I dragged the wreckage to my parents' garden and got up early the next morning to see where, and when, the sun cast an attractive dappled shade. Under their large hawthorn, on a framework of timber and tins, I erected my monstrosity. Then I returned to the original wrecked cars in the distant wood with a number of wooden boards wrapped in polythene. Scratched nearly to death by the now enveloping brambles, I gathered flat carpets of moss and protected it between my stiffened waterproof sheets and transplanted even more woodland vegetation until I had replicated and perfected the original scene in the altogether more convenient and comfortable suburbs of Southampton. Now all I needed was a grass snake.

Funny how you can never rely on your old 'snaky' spots and skills to produce even a wiggle for more than a month when you really need to! I searched and searched, caught a little weedy snake, missed monsters in the mires, and listened to the crescendo of moans about the radical new ornament which dominated the lawn and needed daily watering to keep the moss green. 'Red alert! All hands on snakes!' was sounded to my naturalist friends, and in just a week a suitable reptile was secured — only by then I was on the Farne Islands off Northumbria waving my camera at arctic terns.

Friday morning, the snake was delivered. Friday evening, I got the boat to the mainland. Friday night, all night until 5 a.m., I drove home. Saturday morning at 8.30 I got my father up (with a humbling cup of tea and toast) and between 9.15 and 9.30 a.m. we shot it. He held the tail, I made 'rain' with a watering can to intensify the colours of both moss and bonnet, and enthusiasm flowed even more furiously than my Ektachrome. By lunchtime the local processing labs had done their work and relief oozed from my parents, now able to retrieve their lawn. By 5 p.m. the snake was slithering free, and I was for once very happy with my photograph.

Call it contrived if you like. In fact, call it anything you fancy. You cannot detract from the trouble, the cost, the energy. You cannot deflate me. It's my only 'Desert Island Photograph', the only one of my snaps that I truly like.

There is that bloody distracting bit of bramble at the top, though!

## Adder patterns

SADLY ONLY THREE species of snake inhabit the British Isles: the possibly rare, and definitely elusive, smooth snake; the once common grass snake; and the

adder, which can be found from the south to the very north and is often quite common in open, dry grass or heathland. Only the latter species is venomous and therefore unpopular with most people. However, unless you are unfortunate enough to tread on a particularly dozy adder who hasn't heard you coming, they are easily avoided and thus quite harmless. If you attempt to catch one and are not skilled in the act you may get bitten. Swelling, aching and slight nausea are the usual symptoms, although a few people have specific allergies and are worse affected; but I have been bitten several times and survive to tell the tale, and still count the species as one of my favourite animals!

Adders are easily identified because, whatever the base colour of their body scales (ranging from brown in females through to silvery-grey in males), there is always a dark zig-zag running down the spine. This is visible even on so-called 'black' adders, so there is no excuse for confusion. It was this prominent patterning that prompted me to compose the photograph below, having seen some snakes basking on a bank at the back of a car scrapyard. Only Baldrick would have failed to note the similarity between this pattern and the tread on a pile of discarded tyres!

**Adder on motorcycle tyres**
*Canon A-1,*
*50mm lens, hand-held,*
*Ektachrome 100*

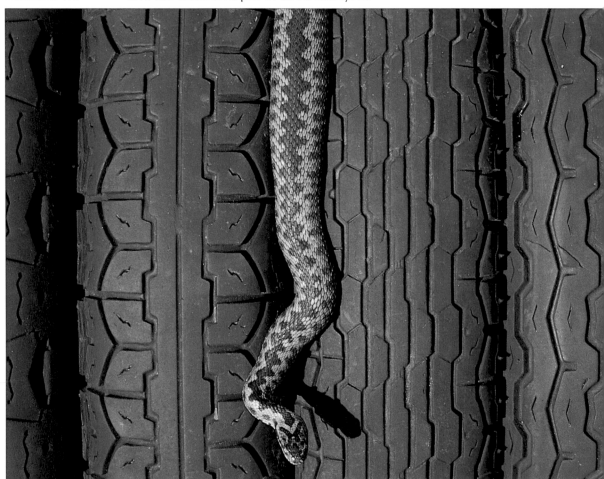

A short study revealed that motorcycle tyres are closer to adders in pattern than car tyres, so I borrowed six from a local fitter and set them up on a frame in the garden. I caught the largest adder I could find, draped it over the tyres and, holding its tail in one hand and the camera in the other, shot several frames on Ektachrome 100. This is just the sort of stunt that will get you bitten, so don't do it. If snakes take your photographic fancy, get some expert help; this will allow you to concentrate on the photograph while the snake gets the careful handling that it needs. Snakes are fragile, soft-bellied animals and they are aggressive when faced with waving lenses, so please take careful heed.

The photograph is, I suppose, a little obvious and, although we know that tyres are normally round, they look flat here. On some frames that I shot from the side, they looked much better — nice sweeping curves — but on these the snake was too harshly lit or simply not comfortably aligned with the patterning on the tyre. The shot is also a little bland on the texture front, wasting the grooves and not enhancing their sculpting.

I wasn't entirely happy, so a couple of years later I took the picture overleaf. On my wanderings over the New Forest in Hampshire I discovered a

very old piece of heathland that had reached maturity — a rare event today as much of the heath is regularly burned to provide new grazing for the local pony population. Given the chance, after about 25 years, ling (more commonly and incorrectly known as heather) reaches waist height, and a single plant can sprawl over several square metres. It then begins to decay from the inside of the tuft and collapse outwards. At this stage, now that the ground is no longer in the dense shade of ling, lichens and other plants finally get the chance to germinate and grow. The same thing happens on a smaller scale for another heather look-alike, the cross-leafed heath, and it is the decaying twigs of this species that make up the top half of this photograph. The lower section is a mat of a soft foliose lichen. I am not sure which species it is since I have never battled through the complicated keys to identify it, but you will no doubt have encountered it before because after drying and painting it is used to simulate bushes and trees on model railway sets.

Lichens are an interesting mix of algae and fungus, living together in a symbiotic matrix, each partner benefiting from the association, but they are often disregarded as boring by naturalists. There are about 15,000 species in Britain, growing from below sea level to the top of the Cairngorms, and they are very often useful as their absence is an indication of pollution. Many are very slow growing and many are

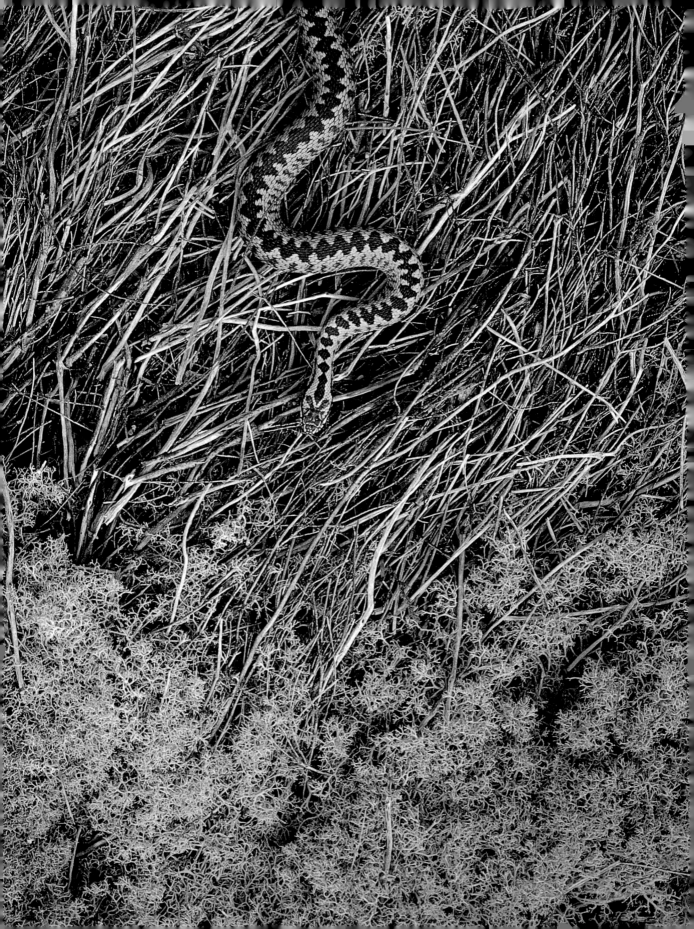

extraordinarily long lived. Many are aesthetically completely dull. This one is not as it matches the background colour of the adder almost perfectly, or vice versa.

I am afraid the aforementioned dangerous 'one hand camera–one hand snake' technique was used again, although this time I supported the camera and 100mm macro lens on my Benbo tripod and fired it with a cable release. This allowed me to pay a little more attention to safety, but it was also necessary because of the strict composition of the picture. I liked the contrast between the soft spongy lichen and the sharp sticky twigs, so I placed the two equally in the frame. Because the snake was lichen coloured it had to be placed on the grey and black zone at the top, its greenish hue echoed in the lichen at the bottom of the frame, and because of the symmetry of the two contrasting backgrounds it had to be central and verticalish. Obviously snakes don't move dead straight, in fact they look weird lying in a line, so I wanted a pleasant, S-shaped wiggle. I tried to tell the snake this, but because they never listen it took about half an hour before she slithered into the perfect position and I clicked. I probably used quite a slow shutter speed ($1/30$–$1/60$ second ) as I wanted the best depth of field possible. Had the snake been slithering, $1/250$ or $1/500$ second might have been necessary — too much for Kodachrome 64 and my focus to handle. I had deliberately chosen an overcast but bright day to flatten the picture and mute the colours and contrast. The first spots of rain probably helped the lichen to look a bit greener. Although I was tempted to release my subject here in apparently suitable habitat, I stuck to the rules and drove a few miles out of my way to release her exactly where I had caught her.

## A cryptic heliotherm

DEPICTING THE smooth snake in its natural environment is difficult. This species, found only on the fragments of heathland in Hampshire and Dorset, is scientifically described as a 'cryptic heliotherm'. Basically, whilst smooth snakes would like to keep their body temperature at about 30 degrees Celsius to allow them to move about, they are so loathe to reveal themselves that they scarcely cook at anything over 23 degrees Celsius. Their crypsis, or camouflage, appears more important than raising their body temperature enough to be active. Consequently they are shy, skulking, slovenly creatures, lacking the panache and glamour of the adder and the charm of the grass snake. Indeed, they hibernate for most of the year and spend the six summer months deep in the roots of heather struggling to summon enough energy to eat five or six lizards or slowworms during this time. These they constrict and swallow whole. With such a low intake of energy they breed only every two or three years and live a long and (as snakes go) apparently intelligent life. They also bite, normally repeatedly, and their tiny sharp teeth make bloody arcs all over your hand. Because of their secrecy, estimates of the British population vary from 1000 to 52,000 animals. Consequently, they are specially protected under the Wildlife and Countryside Act and you must have a licence to disturb them in Britain. The snake overleaf was being cared

**Adder on cross-leaved heath and lichen**
*Canon F-1N, 100mm macro lens, tripod with cable release, Kodachrome 64*

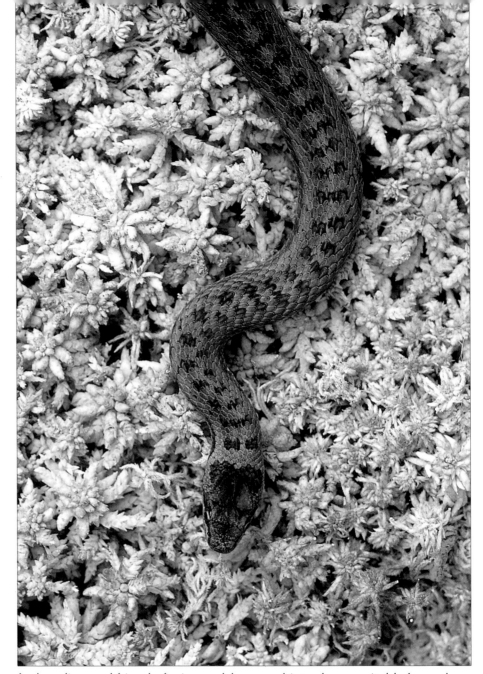

**Smooth snake on sun-bleached sphagnum moss**
*Canon F-1N, 100mm macro lens, tripod with cable release, Kodachrome 64*

for by a licensed friend of mine and, because his tank was suitable for snakes but entirely unsuitable for photographs, I provided my own background.

Sphagnum mosses form damp cushions in the bogs of heaths countrywide and range in colour from yellow, green, brown, even to bright red depending on their exposure to sunlight and the acidity of the water. I had collected a tray of multi-coloured moss and used it for a straightforward portrait of a great marsh grasshopper. I released the insect but left the tray on the roof of the garage where the unfortunate moss was dried and bleached to a crisp. Its texture was fabulous, so I kept it until the following year when my friend very kindly handled the smooth snake, got repeatedly bitten as mentioned above, and provided expletive amusement as I snapped away with my 100mm

macro locked off on a tripod. As with the adder shot on page 70, not all the wiggles worked out, but in this simple portrait it has assumed a pleasing shape. I took the photograph in natural light but lit it through a piece of tracing paper stretched over a wooden frame to diffuse and soften this light and avoid the stark contrast of midday sun. The result is an illustrative photograph which records the pattern and head of the species well. Its shape and the spongy texture of the base are pleasing to the eye and show that a little more care than usual has gone into the portrait.

# Jewel in the Sand

HOT SAND LIZARDS are fast — far faster than your fastest shutter speed — so photographing them in the wild involves slow, sensitive stalking. If you are heavy-footed and clumsily brush all the vegetation, all you will hear is a sudden rustle as a startled lizard legs it away. When you have crawled close enough to shoot, they will know you are there: you will not be able to breathe, your heart will bump, your fingers will ache and your brain will boil with the tension of being face to face with Britain's little Green Dragon.

Sand lizards are, like smooth snakes, generally confined to southern lowland heaths, although they also appear at one coastal site in Lancashire. Definitely one of Britain's most beautiful animals, they are seriously endangered through continued habitat destruction and public pressure, so look after the heath on your visits. Like smooth snakes, sand lizards are protected by law and you need a licence to handle them.

In spring, males are full of adrenalin and regularly jostle among themselves establishing a size hierarchy with the biggest, fittest brutes getting the babes. Females are dull brown speckled-skinned lizards, far less photogenic but equally less visible to predators. So preoccupied are the males with their battling that they can often be quite easily stalked.

You need to search south-facing slopes first thing in the morning when these jewelled monsters have climbed the heather to bask in the early yellow sun. Despite their verdant finery they can be very difficult to see, so move very slowly and stare at all the sunny spots until you are quite dizzy. Try to look three or four metres ahead. If you do disturb a lizard, give it a quarter of an hour and then return more carefully to the same spot, because they will often re-emerge in exactly the same place. Once you have spotted your subject, getting close is basically a matter of common sense. Pre-set your shutter speed for whatever you can hold steady, remembering to allow for the wind blowing the vegetation. Test exposure on something of a similar green and set it half a stop under for better colour saturation, and then start sneaking. Slowness is the key: when you think you are moving slow enough, move twice as slowly. Keep your eye up to the camera, using two fingers under the lens to slowly rotate the focus. Turn off the automatic winder to avoid any noise and start shooting away-off, so that if you do scare your subject you will at least come away with something which may be big enough to crop into later.

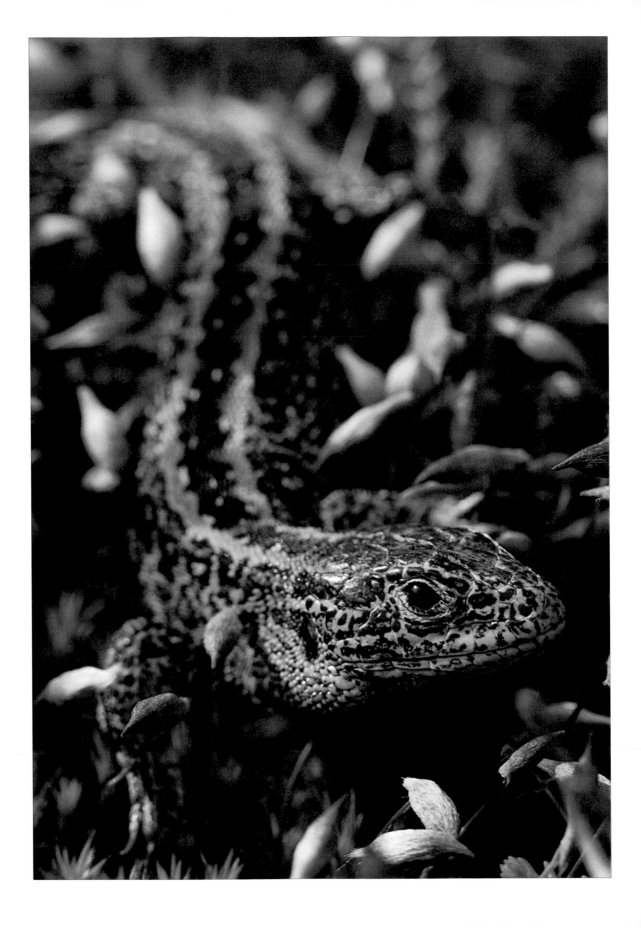

# The World of Amphibians

**Male sand lizard basking on bonfire moss**
*Canon F-1N, 100mm macro lens, hand held, Ektachrome 100 Professional*

THE SPANGLED heathland overlooking Poole harbour on a sharp May morning contrasts violently with my dining-room table overlooking a busy town crossroads one evening during the first week in February. Here in a cold tank sit two common frogs in amplexus, supported on speckled pillows of spawn. Frogs make a good springtime subject. They are common, easy to catch and keep, and are active when many more glamorous subjects are still hibernating or only thinking of migrating back to our damp island. I have seen hundreds of photographs of amphibians in tanks. Most are terribly lit: bright highlights, glowing greens and amphibians wearing sunshine smiles do *not* reflect the reality of a freezing subaqua world with its mysterious tangle

## THE ART OF TANK PHOTOGRAPHY

SHOOTING ANIMALS housed in glass aquaria or vivaria requires some tuition or considerable practice. I had an excellent tutor, and an afternoon spent assisting a professional is worth thousands of written words. Realizing that limitation, I here offer some introductory advice: firstly, it almost always pays, both economically and photographically, to make your own tanks.

Tell the glazier of your intensions, ask politely for the front piece of glass to be checked for any imperfections or scratches and get him or her to do the cutting for you. Tanks must be scrupulously clean and unscratched. Any little smear or mote will catch the light and ruin the image.

Always use the thinnest glass possible for your tank size as this will improve your picture quality — you can actually get away with quite thin glass, even for large tanks, if you build in buttresses and supports. Use a good-quality sealant, but try to be neat as well — there is something distinctly irritating about viewing your prized subject through a greasy grey smear!

Set up tanks at chest height, i.e. high, because cricked necks and aching knees can be unendurable. Always have a sturdy, safe stool or stepladder to stand on to reach into your tank. Set up the tank long before you intend shooting. Water produces irritating bubbles of oxygen in freshly filled tanks, and it will take days for any muddy or weedy material to calm down and look natural. There is one monster problem: once your silty or sandy background has settled nicely, you will introduce your subject which will either disturb it or hide in it. The solution is simple — you need to employ the two-tank technique!

For this, build a deep, strong, semi-permanent tank to house all your mud and weeds and another thin, small space-restricting tank to stand in front of it to house your subject. (You will need to include a few clean shreds of support in the subject tank — otherwise your animals will look pretty silly resting on the 'invisible' glass.) In this way there is no chance of the newt, frog, fish or insect ever disappearing into the murky depths of your set. In fact, make the tank so small that it is difficult for your subject even to swim out of your frame! Simple, eh!

It is best to use a tripod — not merely to avoid camera shake, but also to free both your hands to chivvy subjects into the required position in the tank with soft paintbrushes. Mirrors are a great asset for reflecting light into the tank but remember that in a real pond or stream light can only come from above — so fill in sparingly.

Lastly — the real headache — your own reflection in the glass or, worse, that of next door's washing. My only advice is to get as much black cotton twill or velvet cloth as you can and surround the tank with it pegged to stands. Sometimes you will even have to shoot through a hole cut in it for your lens. If you want an easy introduction to tank shooting, read Rommel, Patton or Montgomery — leave a bundle of wrestling toads to the experts!

of fronds and silt streams. Most photographers completely forget that the light should come from above and should be minimal because these animals reach their sexual frenzy at night. The best photographs I have ever seen were subtle, rich tableaux taken by the friend who taught me how to overcome the problems associated with shooting with tanks. Seeing no real need to replicate his success, I tried to exaggerate the macabre, sinister, watery eroticism by reducing the scene to a series of ink-blot shapes that remain distinctive enough for the subject to be recognized.

The shot below was lit using a 100-watt anglepoise lamp. I taped a piece of tracing paper to the back of the tank to diffuse the light enough to eliminate flare and shone the lamp through this to create the silhouettes. Because room lights are very orangy compared with daylight's white or blue hues, I used Ektachrome 160 Tungsten, a film that is especially balanced for this colour temperature of light. The result is a slightly unnatural picture, very sanitized with no weeds or mud, but I was pleased with the mood of secrecy that cloaks its watery scene.

Common toads are as familiar and easily obtained as common frogs but are easier to work with out of water because of their tendency to walk rather than jump. A frog out of water can be a bit of a slippery handful and you need to take great care to prevent it battering itself to the point of stress or injury. In fact, if you want to shoot an amphibian terrestrially, give frogs a break and stick to toads. Their warty textured skin is more interesting as well.

A nocturnal torch-lit visit to a clean local pond in February or March will normally provide a host of subjects, but don't over-collect. Two or three

**Silhouette of frogs on spawn**
*Canon A-1, 50mm lens, tripod with cable release, Ektachrome 160 Tungsten*

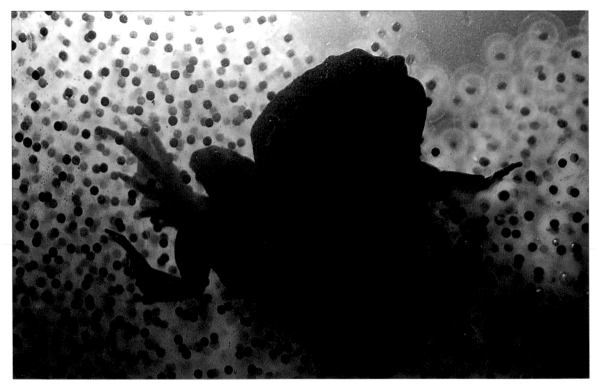

similar sized animals will mean that you can alternate your subject to minimize stress to any individual. Also remember that the toads have come to the pond with a purpose, and because no one or nothing enjoys *coitus interruptus*, return them within a couple of days to allow them to do what toads like to do in balls of up to 20 or more!

The shot below was taken in a plastic greenhouse gravel tray on a table in the garden. Such trays make useful shallow ponds and can be used to great effect with low morning or evening light. The pure areas of reflected sky can provide a clean abstract background for any subject you chose. Paint the inside matt black to reduce reflections and set it all up on a table with a working height that won't give you a crick in the neck. Unless you want reflections of washing lines, pylons and next door's window boxes, you'll have to find an open view to shoot against, or position a very large piece of coloured card behind your 'mirror pool'. In this instance I taped up some black card to outline the shining back of the wet toad. You will have to shoot with your lens as nearly level with the subject as possible to avoid seeing the tray bottom. For this shot my lens hood was resting on the tray's edge. However, I feel that while the subject and approach have potential, this particular photograph has failed because of the shallow depth of field. My excuse is that it was one of the first photographs I ever took, but I now wish I had atuned my photo senses earlier and stopped down more to give the shot the sharpness it needs. The toad was quite still so a slower shutter speed could have been used — even 1/2–1/4 second. This would have permitted a greater depth of field. Bah!

**Common toad**
*Canon A-1, 70–210mm lens, tripod with cable release, Kodachrome 64*

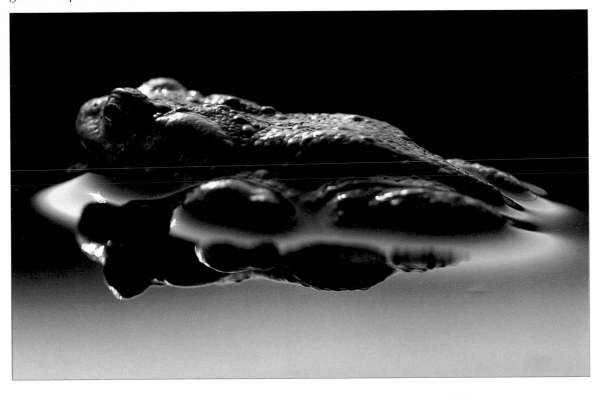

# INSECTS

THERE ARE more species of insects and spiders in Britain than any other group of animals, and they make some of our most attractive photographic subjects. Although the majority of our 20,000 insect species are so small that they are beyond the scope of most conventional macro photography — microscopes and laboratory techniques are required to capture bristletails, springtails, proturans, stylopids or thrips on film — there is still plenty of scope for an imaginative approach.

Butterflies must rate as firm favourites, due to their splendid colours, sun-loving habits and accessibility — brimstones and small tortoiseshells, for example, can be found countrywide on any area of nettled wasteland or overgrown garden and make excellent subjects for the beginner. Together with moths, they also undergo a larval stage as caterpillars, many of which are large, colourful or bedecked with wacky wigs.

Don't overlook bees, beetles and bugs. Many of these have evolved into remarkable ecological niches with quite bizarre body styles. Consider the diversity of form amongst wasps, for example, where some solitary varieties have grossly elongated ovipositors used for laying eggs into the living larvae of beetles deep in rotting wood. Beetles include the almost tropically horned stag beetle and the burnished bodies of the nectar-loving rose chafers. Bugs encompass sap-sucking shield bugs, bloodsucking assassin bugs and a host of remarkable aquatic species — water striders, water boatmen and water scorpions and, my own personal favourites, the long-legged and predatory pond skaters. And then there are the spiders! Not popular with arachniphobes, but Britain's 480 species offer an incredibly varied spectrum of colour, shape and behaviour.

Many insect species can be manipulated to a greater extent than their vertebrate counterparts, and their very abundance often makes it easier to collect and photograph them. However, neither of these factors should allow you to lower your established moral codes of conduct when handling wild subjects. Using the right techniques and often a juggernaut of patience, you can coax brilliant images from insects but, as in all areas of natural history photography, you should explore their ecologies, understand their behaviour and react sensitively to their surroundings. Then, given a little original thought and design, you can produce some novel and striking pictures.

## Star Trek refugees

MORE ALIEN than *Alien*, more bizarre than any Dali drawing, butterflies are nothing but astounding. What zoologist, given a design brief, would come up

**Brimstone butterfly on downland flowers**
*Canon F-1N, 100mm macro lens, tripod with cable release, Ektachrome 100 Professional*

with a creature that has a million microscopic sense organs on two head stalks, and eyes made up of thousands of lenses? Who would have added a spring for a mouth and tiny breathing tubes, and which wag would have defied the laws of physics to design those stupid wings?

Strapped to a system of muscles that has propelled insects for the last 270 million years, these slight slivers of dry tissue can start, stop, accelerate and speed without any aerofoil action and, despite atrocious technology, have developed a vortex-driven system of flight mechanics that enables not only a pretty fluttering but also migration over thousands of miles. Butterflies are a miracle of form and function, so different from ourselves that they might as well inhabit another planet.

The brimstone is my favourite butterfly. The males ignite spring with their sulphurous flaring in the bleak brown hedgerows and continue to burn just as brightly all summer long. Simple, yellow and shocking, this is one of nature's fireworks resting on some downland blooms.

# Insect Reflections

REFLECTED IMAGES, and often their real subject, have always held an interest for me and thus became one of my first self-assignments. They can offer perfect symmetry or weird distortions and, due to their obvious reflection of light, often transform a normally lit view into something mischievously surreal. Unnatural reflectors abound — chromed hubcaps, huge glass office blocks, shiny sided cars or your bathroom mirror regularly reflect and distort our world into weirdly warped washes of reality. Trying to find or even coax a subject in front of such a mirroring device can often be difficult, however, so it is best to rely on relating it to nature's greatest natural reflector, water.

Perfectly still water can act as a clean mirror on any scale. A still lake at sunset can reflect an entire landscape whilst a dish on the draining board can hold a fragment of your kitchen in duplicate. Using trays and tanks you can actually fashion sets based entirely around reflected images. Manipulated conditions call for manipulatory subjects — that rules out birds, mammals and, to a great extent, fish (they just cannot be given directions!) and leaves us with plants and insects. Plants work well on a large scale, shot *in situ*, emerging from or fringing still streams, ponds and puddles; but insects can be tempted into your control at home. These animals are easier to catch, keep and control than most others and because such a great variety show an affinity for water in the larval and adult states, they are a number one choice for budding reflectophiles.

## Beetle bonnet

**Stag beetle on bonnet of Daimler hearse**
*Canon F-1N, 28mm lens, tripod with cable release, Ektachrome 100 Professional*

CARS RIVAL wild things in life for my passion and wild cars stir the greatest amount—old, English, bespoke, growling sports cars with six-cylinder alloy engines, wire wheels and the rich aromatic mix of leather interiors and aluminium skins. I drove to paradise once when I spent a day watching a male red-backed shrike from the bonnet of an Aston Martin DB6. Fabulous!

# Wing-walking beetle

THE BOLDLY MARKED burying beetle was not such a challenge to capture on film, but these carnivorous, thick-set and heavily built undertakers require grizzily Burke and Hare tactics to collect. There are eight British species but the two red-banded types are the most common and can be found under and amongst the decaying carcasses of small mammals and birds on grasslands countrywide.

They have an acute sense of smell and their powerful flight soon leads them to fresh corpses. Males often arrive first and, after a bite of lunch, climb atop the carrion and release a strong chemical attractant to lure a female. If more males arrive they are tolerated until a female alights and then some macho-male fighting breaks out until just the pair remains. They mate and then begin to dig under the carcass, pushing all the soil aside until the dead animal sinks into its grave, eventually covered by some 5–7 centimetres of earth. It is then stripped of its fur or feathers. Once the female has laid her eggs she drives away her mate and finally gorges herself. After five days the larvae emerge and are fed regurgitated flesh for the first few hours by the diligent mother. Indeed, this process is repeated after each of several larval moults, until they finally pupate and emerge as adult beetles in about two weeks.

This is a gruesome but remarkable life style and also one which makes finding the beetles difficult. If the corpse is small — say,

a vole or a shrew — it is very quickly buried and you will never find your beetles — and scouring hillsides for dead shrews is not a very rewarding occupation anyway. Consequently you have to provide your own corpses. Road kills, collected in polythene bags and stored in the freezer, are a useful source. Defrost them, place at a marked spot around your local shrubby areas and visit a couple of times a day. You will need to be quick to grab the beetles as they will rapidly burrow into the flesh or soil to escape; but as they do not bite, a fast draw-hand should fill your jar.

I chose to put mine on the wing of a dead woodcock, the nicest road kill I collected, which I had pinned open on a board. It formed a pleasing, plain abstract background with its neat curves of feathers. These beetles are real Houdinis when it comes to getting away. As they run very fast, I set up my tripod above the wing, pre-focused, pre-exposed and shot blind with a cable release in one hand and the beetle in the other, putting it down on the wing and moving my hand out of the way for a fraction of a second while I took each shot. Even so, you will need a shutter speed of at least $1/250$ second to stop them (one leg is still blurred in my shot), and if there are any crevices in your carcass they will be into them in a flash. I also used a sheet of tracing paper to diffuse the sunlight since the shiny-backed beetles would otherwise have been too contrasty.

**Burying beetle on woodcock wing**
*Canon F-1N, 100mm macro lens, tripod with cable release, sunlight through diffuser sheet, Ektachrome 200 Professional*

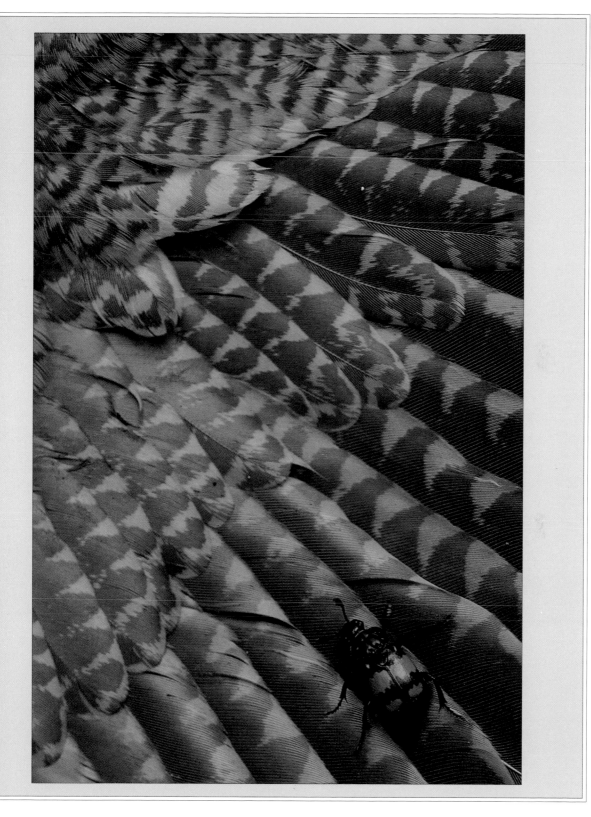

It was obvious, therefore, that when after an early morning prowl around an old churchyard poking my lens at dewy spider's webs, I spied a magnificent old Daimler hearse outside the door, I would engage its lazing owner in an automotive discourse. (Talk for hours and hours about cars, my girlfriend calls it.) Paintwork was the topic of the day because the bottomless black sheen of this monster's bonnet was quite magnificent. A lustre to lust after. Number of coats, paint type, polishes and perfection — we prattled on and on. As I circled the car maliciously looking for chips, scratches or micro blisters, I was drawn to the dark reflections on the doors. I snapped a couple of self-portraits with door handles coming out of my ears and then, as I stood up, I saw the picture on page 81, minus the beetle.

I knew that I only had a few minutes before the car would be gone, so I searched furiously around the graveyard for a subject. Oak leaves, oak galls, a snail's shell — anything, anything, anything. I began to sweat, I really did. Here was a good picture begging for a celluloid future and not a subject in sight. I returned in hopeless dismay to the Daimler and there in the gutter, only a couple of metres away, was this male stag beetle.

Britain's largest beetles, growing to about 5 centimetres in length and equipped with huge horns, 'stags' are most frequently seen on warm summer evenings. Sadly this chap had obviously collided with something the evening before and now he lay on his back, stunned, gasping for air in the all-too-dry morning sunshine. I picked him up, feeling very sorry for him, and studied his huge antlers. I had once presumed these to be a silly overdevelopment for sexual selection (you know the theory: big horns = big genes), but when I prodded them with my finger and they closed on me for ten minutes of agony I learnt otherwise! This morning, however, there was no time for such physiological experiments. I set up my camera as quickly as possible, showed the car's owner exactly what I wanted to do and he grudgingly allowed me to place the beetle gently on the bonnet. Within three shots I had this picture and could hardly contain my elation. With the car gone I left the beetle under a piece of bark in the shade of a nearby tree, hoping that he would survive the day and recover enough energy to see him through the forthcoming evening. I was going through a rather narrow-minded spell, taking many reflection photographs, but this one was possibly the most radical and most successful: it later won the Composition and Form Category in the Wildlife Photographer of the Year Competition, 1988.

## A sleepy damsel in silhouette

EYEBURST-BLUE sparkling gems, fluttering hot and so daintily about the emerald sedges. Banded agrions, characterized by their broad, banded wings, are simply made of colour. Males burnished blue, females greenish bronze, these fabulous insects reach sub-swarm proportions over the slow-flowing streams of southern England in July.

Almost all dragon- and damselfly photographs focus on the colour aspect, making them look like Fabergé or Lalique gems; but after watching them resting after sunset on my local river Itchen, I chose a 'Japanese silk-painting

**Male damselfly and its reflection on willow sprig**
*Canon A-1, 70–210mm zoom lens, tripod with cable release, Kodachrome 64*

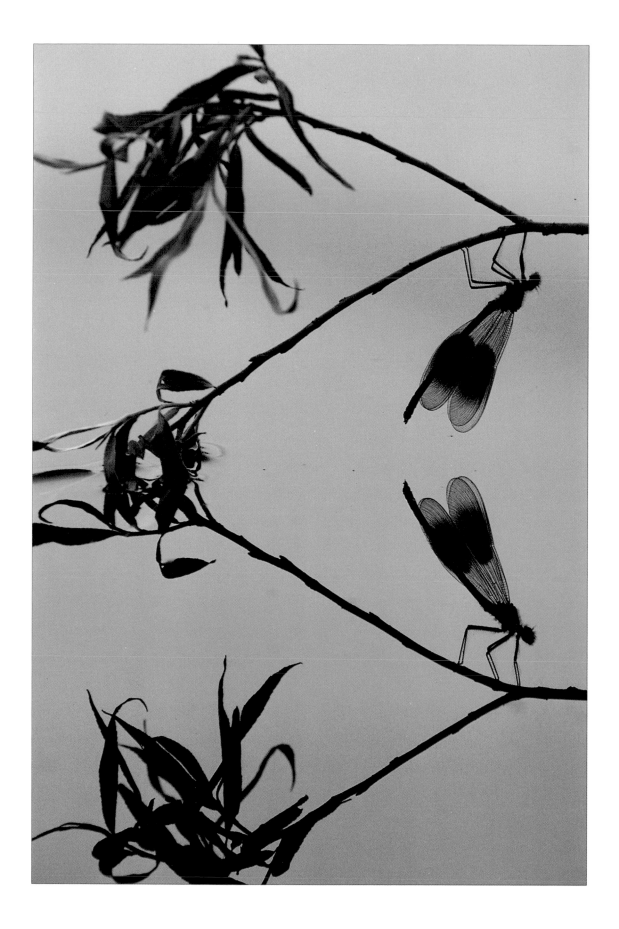

silhouette look'. These insects' bodies are so complicated, so alien to our own, that in full close-up they are somewhat ugly to most people and attention is drawn to their dominating colours alone. By reducing the insect here to a neat black outline, rimmed with downy hairs, we see a simplified elegant shape, and without the distraction of its electric blue hues we can see the myriad veins in its delicate wings. The vulgarity of brightness is gone. It is cool, relaxed, becoming torpid in the peace of a still evening and mated to a perfect reflection of itself on the water's surface.

I spotted one of these damsels settled out in the middle of the river one night through my binoculars and spent some time finding an accessible replica of the scene. First I searched for a narrow drainage ditch that ran west to east to get the setting sun in the correct place; then I chose a stretch of water about three or four metres long, which I cleared of any fringing vegetation; finally I added my own broken sprig of willow. I returned at dusk on a clear, still evening with an assistant. As the sun set he kept the local male damselflies from choosing other roosting sites by vibrating all the streamside vegetation over about 20 metres either side of my watery set. I erected my battered Benbo tripod in the middle of the ditch and jammed it firmly into the mud to prevent any ripples ruining the reflection, which I wanted absolutely perfect. I straddled the ditch, my back aching like hell, and shot five or six frames through the 210 end of a zoom on quite long exposures (because of the low light and slow film — Kodachrome 64). I got the symmetry I wanted and some very muddy feet, but if I could do the picture again I would get more depth of field to make the actual (not reflected) sprig of leaves really sharp. Their softness adds some perspective to the shot, and I wanted it flat black and gold. However, I always get a sense of satisfaction when I show this photograph to people and they juggle it to see which is top and bottom. Their confusion prompted more shots in my reflection series.

## REFLECTIONS – FOCUSING AND DEPTH OF FIELD

FOCUSING ON reflected images and their real subject can be tricky as the two do not share the same point of focus. Sometimes the difference is negligible; at other times, you need to give it a little thought — especially if you want a distant background sharp as well.

Your greatest asset is a good depth of field. Generally in the wild you will be relying on low early morning or late evening light to generate a perfect reflection from your watery mirror and this low angle of incident light means low intensity as well. Low light in turn means using either a high-speed film, which may be undesirable, or a long exposure, which can be problematic if the 'mirror' is not perfectly still.

Here is a tip. Focus on the subject and look at, or even mark, the distance scale on the barrel of the lens. Next focus on the reflection and again check the scale. This is the range of focus you will need in order for both subject and reflection to be sharp. Take an exposure reading and gauge the slowest possible shutter speed you can use (dictated by any movement in your subject or the reflective surface). Use the depth of field scale on the lens barrel to cover as much of your measured field of focus as possible and set the aperture accordingly. If you cannot have it all you must choose which end, subject or reflection, you want sharpest. If your subject is still there after all this, take the photograph and smile smugly!

# A boatman becomes boatmen

THE UNDERSURFACE of still water can be an equally perfect reflector as this bizarre portrait of a water boatman below illustrates. This is not two boatmen (or women) joined backside to backside, but one breathing through its backside as it rests tail up to the water surface. The upper 'organism' is a reflection of the lower one, a neat way of seeing both sides of a boatman and producing a nicely confusing picture. I spotted this one sunny afternoon whilst peering into my outdoor aquaria at tadpoles (entirely unsuitable subjects as they are black, fairly amorphous and too active to cope with).

Water boatmen are common aquatic bugs which inhabit still waters countrywide. The largest can grow to 1.6cm long — big enough to photograph with standard macro equipment. Their name derives from the way they vigorously 'row' their long, hair-fringed hind-leg paddles. They are ferocious predators, feeding on creatures as large as tadpoles and small fish. The prey is pierced by a sharp stabbing organ folded under the head, the rostrum, which injects a toxic saliva; this digests the soft tissues into a soup which, in turn, is sucked up through the same organ. Water boatmen can bite us. And it hurts. Initially it feels like a wasp sting; the pain subsides after a few minutes with no more ill effects, but as you grope around in a bucket of pond dippings it never fails to make you swear.

In a conventional tank, photographing the undersurface of water is impossible because of the distortions which arise from pointing your lens

**Water boatman and its reflection**
*Canon A-1, 100mm macro lens with 50mm FD extension tube, tripod with cable release, Kodachrome 64*

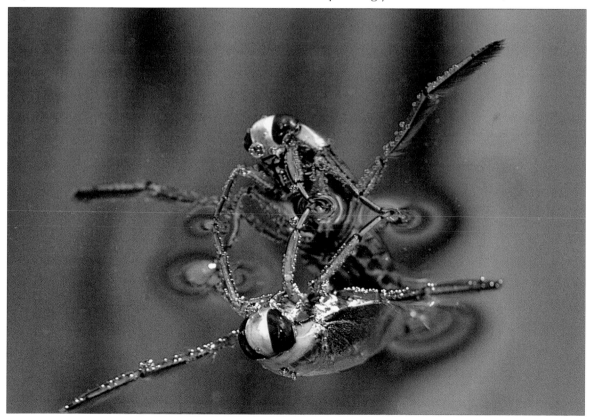

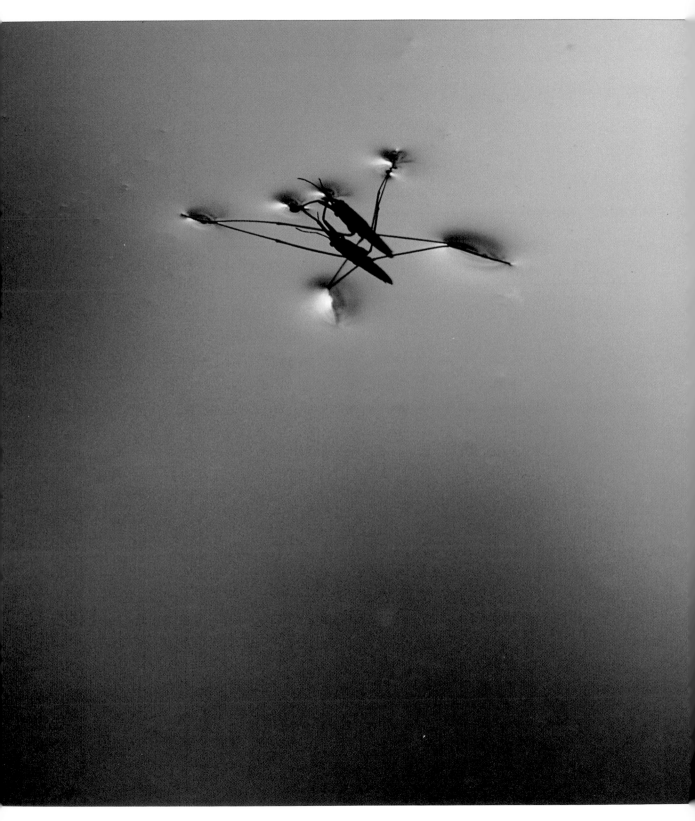

**Pond skater plus reflection**
*Canon A-1, 100mm macro with 50mm FD extension tube, tripod with cable release, Kodachrome 64*

acutely through the glass. For minimum distortion your lens has to be at 90° to the glass. Using scraps from a local glazier, I made a small V-shaped tank so that I could look straight through the glass at the water surface. I set the tank on a high bench in front of a bucketful of sedges for a natural reflected background and, using natural light and a small reflector to fill in the insect's underside, took this shot on Kodachrome 64. One problem you will encounter is dust and hair on the water surface, which will ruin the image. With non-animate subjects you can disperse the dust by adding a drop of washing-up fluid, but this technique will drown any insects: the detergent reduces the surface tension of the water, with the result that the insects are no longer supported on the surface and water seeps into their breathing tubes. All you can do is try to work in a dust-free environment and remove any real irritants with a paintbrush. Boatmen are very active animals and will soon drive you mad with their persistent diving about. Turning your back in frustration can be fatal because they will soon tire of your tank, climb out and, because they are strong fliers, be gone by the time you return with more Valium. Considerable patience is your only hope. Good luck.

## A metal walker

ANOTHER VORACIOUS predatory bug is the pond skater, a familiar species that shares the boatman's affinity for the water's surface, but from the aerial side. Skating on unfrozen water is facilitated by pads of water-repellent hairs at the end of each pair of their middle and hind legs. The depressions these produce in the surface tension of the water can be clearly seen in the photograph on the previous page. Rapid rowing speeds the skaters to any prey, usually another less accomplished swimmer such as a thirsty fly, wasp or bee, whose drowning throes have been detected by the sensitive forelimbs of the skater. These rest gently on the surface and are free to manipulate a victim beneath the head where a rostrum similar to that of the boatman does its gruesome job. Unlike the latter species, however, pond skaters do not bite humans and in fact require careful handling because of their fragile gangly legs.

The photograph on pp. 88–9 of the largest skater I could find was taken in a plastic gravel tray of the type normally used in greenhouses. Measuring 40 × 140cm, painted matt black and set up on a bench in a clear part of the garden, it produces a perfect reflection of the sky when lit by oblique or low light. Sunrise, sunset or thundery black clouds split by sharp sunshine are favourites and I shot the insect shown on just such an afternoon. (See also the common toad shot on page 77.) I liked the sheen of the water which the robotic form of the skater has made almost mercurial with its 'footprints'. The large expanse of empty water emphasizes its smooth, metallic appearance and the dappled light from the cloud reflections gives an interesting patina. There is no real colour, yet this colour transparency has that 'toned' appearance more commonly seen in special black and white prints. The minimalist shape of the picture has further alienated the subject and concentrated the focus entirely on the form of its body. Placing the subject

in the top right-hand corner has given the picture a more dynamic composition. Centrally placed subjects often seem static and it is a good idea to divide your frame into thirds, vertically and horizontally, and place your subject on one of these invisible thirds. I quite like it.

# Insect Mosaics

BUTTERFLIES AND MOTHS are necessarily ephemeral. At the winged adult stage, their *raison d'être* is to disperse, find and choose a mate and, for the female, produce and lay eggs in the right place at the right time. The longest-lived adults, migratory species such as the North American monarch butterfly, may live for a little over twelve months but most British species fly for only two or three months (those that hibernate over winter surviving for perhaps seven or eight months). By far the majority never reach old age. Parasites plague the pupal stage; fungus and the attentions of insectivorous birds and mammals are also a danger. The emerged insects, too, are prey to a whole host of birds and mammals, and bad weather, cold temperatures and disease destroy many more. Only the fittest and most fortunate survive to pass on their genes to the next generation.

Such high rates of mortality are, of course, not confined to butterflies and moths, but they seem more striking in these fragile life forms. So gossamer-thin and weak are their structures that, once dead, decay is almost instantaneous. How often do you see dead butterflies in the gutter, on the lawn or beneath a tree? Almost never. Thus in *rigor mortis* they become rare gems, still sparkling but with a strange, morbid allure.

Here are a few of my funereal intrusions.

## Drowning in numbers

THE STARK chalky white of the two magpie moths overleaf contrasts dramatically with the dark water and peat-stained stones. Their perfect curves, displayed flat on the surface, complement the pebbles and a graphic image results. I feel there is a desolation here, due not only to the dead moths but exaggerated by their being in a medium that is not their own. The bleakness of the day is reflected in the slivers of dead light that line the stones, a hard and unfriendly mantle for a fragile insect. There were, in fact, hundreds of drowned moths in this stream; the scene was sadly spectacular, as if someone had dumped confetti in the water. The scale of the carnage was impossible to depict photographically: with a wide-angle lens the moths were too small, too dispersed and too easily lost in the area of white sky reflected in the stream. There were no large masses of corpses. There had not yet been time for them to clog up any narrows, indeed they would disintegrate long before then. Choosing the most photographic duo I could find, I set up my tripod and shot with a zoom, varying the size of the moths in the frame. This picture worked best; with a wider angle, the pattern of pebbles became too complex and distracting. However, I took the photograph at great personal cost.

**Drowned magpie moths in Hebridean stream**
*Canon A-1, 70–210mm zoom, tripod with cable release, Kodachrome 64*

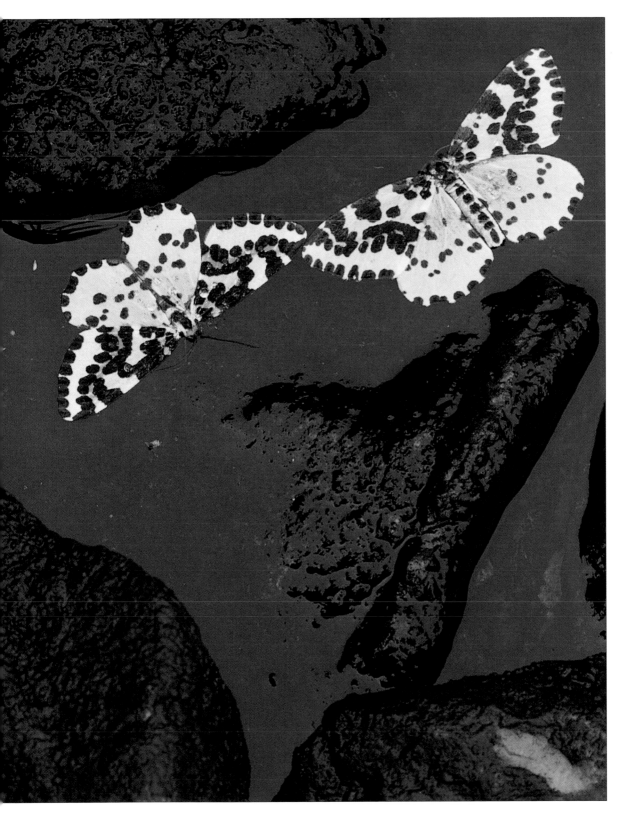

The carnage was the result of a sudden cloudburst on the eastern side of South Uist in the Outer Hebrides. These remote isles have survived the agricultural onslaught that has destroyed most of mainland UK since the end of the last war, and in July the unfenced fields are ablaze with a remarkable density of wild flowers. Corn marigold, ragged robin, tufted vetch and a host of orchids mix with the verdant swards of flags to produce a show the like of which I have never seen anywhere else in Britain. Such an abundance of nectar gives rise to a great density of insects, not of great diversity because of their northern latitude, but including the fiercest squadrons of horseflys I have ever fought! To the east of these sandy meadows, known as Machair, lie some tall hills which act as rain stops for any incoming clouds, and it was here that the host of moths was washed away. Wet, cold, and up to my waist in sticky heather, I was here looking for otters as it is possible to get good daytime views of these secretive animals in the quiet sea locks that invaginate these shores and, whilst I snapped this flotsam, my friends did just

**Dead swallowtail on frozen wire with hogweed**
*Canon A-1, 70–210mm zoom lens, tripod with cable release, Kodachrome 64*

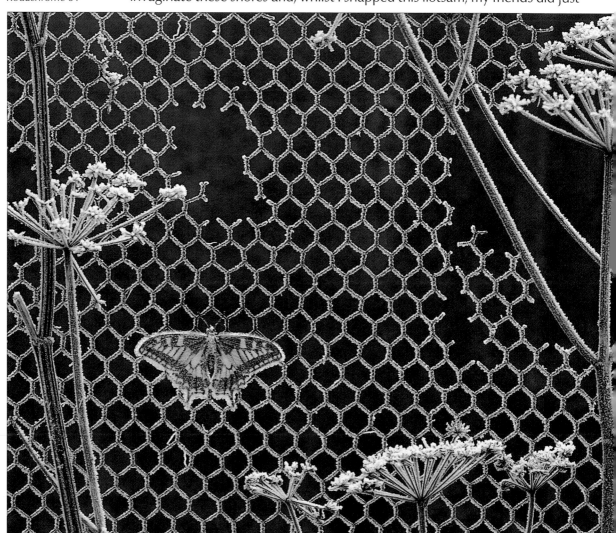

that. In fact, they managed to get some average photographs of one dog otter munching on shellfish. At the time I was gutted; but, as the next anecdote relates, photographic dedication can produce a happy ending.

## Nuclear winter

HEAVY RAIN must account for the deaths of countless millions of butterflies and moths, but the horrors of a hard hoar frost are not something they normally have to contend with. After a series of early morning visits to a local riverside, snap-crackle-popping through diamond-dusted grass and pointing my lens at 'sugar'-coated leaves, thick necklaces of normally invisible horse hair snagged on wire fences, brittle hogweed heads and whitened woodland, I was dissatisfied with my obvious 'all been done before' pictures. I had, however, made a shallow study of heavy frost and its formation on wire and plants, and used this as the basis for designing this photograph. I wanted to create a bleak, graphic image of wintry devastation. Chicken wire, flat and

uniform, provided a harsh, anonymous setting, and the straight stems of hogweed, sprouting fragile hairs of ice that would be lost under one single hot breath, added a contrast in shape and texture.

Remembering the moths on South Uist and imagining the devastation that such levels of cold would wreak on such fragile insects, I came up with a butterfly as a subject to be stranded on my wire. Swallowtails are a glamorous species which survive on a few East Anglian fens and fly in June and July. Their attractive colour and patterning, however, makes them favourites with collectors and consequently I was able to obtain a long dead but perfect specimen in December. I must confess that I find butterfly-collecting utterly disgusting, even if, like this insect, they are raised in captivity and murdered the minute they inflate their wings. Surely the days are gone when people think these fabulous organisms look better lying symmetrically in dusty, dark drawers instead of flitting about in the wild. Like fireworks, part of their appeal is their short-lived fragility: true beauty never lasts, it is ephemeral and destroyed by age, and age for a swallowtail is measured in just a few short hours.

On Christmas Eve I checked the weather forecast and set up my bulky chicken-wire frame on the riverside, breaking some segments of wire to make it more interesting. I tied on some hogweeds to reduce the bleak geometry of the shot and reset the butterfly's 'wings up and out' display position into the way that it relaxes naturally when alive. At about 8.30 a.m. on Christmas morning I took the picture and was well

satisfied with my photographic depiction of a potential nuclear winter scene. The muted colours produced by the frost crystals saddened the swallowtail and in close-up it looked like a marzipan cake decoration, its vibrant design reduced to a mere impression of reality.

During the half an hour or so that I was messing about with my camera I had heard some vigorous but intermittent splashes from the nearby but out-of-view river. I presumed that it was a coot or moorhen unwrapping its seasonal presents on the mud, but having finished packing my gear my curiosity got the better of me and I wandered over to the bank. It was only five months since I had missed the superb show on the Western Isles, but now fortune smiled in my direction and I got a Christmas present I'll never forget. There, some 15 metres away on a tiny mudspit, sat a spiky, wet and pin-sharp otter. It spotted me straight away and slid soundlessly into the water, pausing twice to glance back at my trembling binoculars before it dived and vanished from sight. Such a daylight view in England is worth a hundred in the Hebrides, and I so nearly missed it because of another dead insect!

## Beautiful wreckage

I MUST HAVE become somewhat obsessed by the fragility of butterflies, because the following year I was set up and ready to photograph the severed wing of a tortoiseshell butterfly which had erroneously entered my friend's garage and wound up in a spider's web. Long devoured, the absent spider had left one forewing stuck to the lattice of the web. Lit by sharp sunlight, it looked like a tiny shard of a stained-glass window. I shot a whole roll of film, but didn't manage to capture the magic of the scene at all. To make the web visible I misted it with a houseplant atomiser, but, despite the spangled pane and its dew-drenched support, the pictures were unspectacular.

The tragedy of lepidoptricide festered in my mind until I visited a large, public, tropical butterfly house on a filming job and, whilst chatting behind the scenes, spotted a binful of the beautiful wreckage of hundreds of its dead exhibits. Basically, leaving these dead gems to decay in view of the wandering visitors is not considered good public relations so they are retrieved on a daily basis and stored decorously out of sight. I left with the lot in a large film box, having instantly recognized the potential of photographing one of the most shocking mosaics in nature.

This is almost Pop Art, a gaudy, random Sixties image influenced by Jackson Pollock. The colours are

extraordinary, as befits a spread of species from tropical jungles all around the world, but the scene is one of horrible damage, dismemberment and decay. As a child my father had told me that on board merchant ships cruising down the coast of South America he had seen the funnel filters choked with the corpses of thousands of brilliantly coloured butterflies. I have never forgotten this image and have tried to replicate it here.

To take the photograph you see below I simply laid the carcasses on a black cloth, arranged a few of the better preserved specimens and adjusted fragments to balance the colours over the frame. I lit it through a tracing-paper diffuser and, with the camera shooting straight down, got what I wanted in two shots, the second shot half a stop underexposed for better colour saturation.

**Tropical butterfly mosaic**
*Canon F1-N, 100mm macro lens, tripod with cable release, Ektachrome 100 Professional*

## Shadow play

THIS PHOTOGRAPH of the shadow of an oak bush cricket cast onto an oak leaf is best described a 'a simple gimmick'. Whilst probing, as one is prone to do, beneath an oak bush one sunny afternoon, I noticed just such a shadow and the idea was born. Of course, as usual the situation was unphotographable in the wild; it was windy, the cricket shadow was not clearly defined and I could see part of the creature's body

protruding from behind the leaf. The leaf, too, was a withered example, partially shaded by others above and too high and distant to reach with my macro lens.

I collected a few sprigs of oak leaves, each carefully chosen for its unblemished underview, and a few crickets which I tapped from their resting places into an upturned umbrella, bottled and transported to my living-room windowsill. Here I sellotaped the best leaf I could find at 90° to the glass, making a little ledge for the insect to perch on. Then an obvious problem struck home: using a macro lens and 50mm extension tube to give a lifesize image, none of the leaves was large enough to fill the frame. I could see daylight around the side; worse, I could see sellotape and my dirty windowglass. That night I released the crickets back onto their bush and put the picture into storage.

For the remainder of the summer I regularly checked every oak tree and bush I encountered, and became familiar with every variation in the size, texture, shape and transparency of *Quercus robur* leaves. There was no correlation between tree size and leaf size, or between shade and leaf size, in fact between *anything* and leaf size! All the leaves I examined were too small, and in the autumn they fell off the trees to join the long-dead crickets rotting in the soil below.

The following July I was filming some silver-washed fritillaries for the BBC in a local wood when I remembered the oak cricket dilemma and checked a few bushes. To my great pleasure I found one 4-metre-high shrub with positively enormous leaves, at least three or four times the normal leaf area. Re-collected crickets on a re-sellotaped leaf shelf produced the photograph here with no difficulty at all. (Well, the crickets were a bit fidgety.)

**Shadow of oak bush cricket on oak leaf**
*Canon F-1N, 100mm macro lens and 50mm extension tube, tripod with cable release, Kodachrome 64*

# Natural Combinations

WHEN CLAUDE MONET painted his famous poppy field, I am sure there were not two parasoled ladies floating through the weeds. If there were, they would surely have been paid models. Monet must have seen countless fields of poppies and perhaps one particularly vibrant verge caught his eye. In his mind he probably cropped and exaggerated certain elements of his image, perhaps even excluding some detail which did not fit his ideal. Finally, after sketching and much manipulation, he put paint to canvas and immortalized his vision for millions to enjoy. A genius and great impressionist master, but also a fellow lucky to be using paints instead of photographic film! How many poppy fields, or other vistas and visions, have inspired you to lift your lens only to cringe at some immoveable object — a parked car, telephone wire, pylons, a tatty fence or an ugly tree creeping into your frame — which ruins the purity of your picture? Major landscape surgery is beyond most of us so we drop our lenses and walk away dejected. Monet simply painted over them or left them out completely, such is the freedom of the artist. Reality is the photographer's only medium and yet his greatest enemy. Therefore to master the art of photography you must make a slave of reality, you must manipulate it to your own ends.

Certain aspects of objects in certain situations appeal to me aesthetically, but there is often no real subject or point of interest and the result is too abstract, even pointless, in isolation. The photographs that follow are a product of two or more settings or objects, seen at different times and in different places. Because each component seemed worthy of a photograph, even though circumstances conspired against me taking it at the time, I later re-created the image, manipulating the lighting, colour, contrast and composition as necessary in order to maximize its photographic potential. Thus, very simply, I have taken control over the image.

## Aegean outline

ALTHOUGH IT is an abstract, devoid of any signs of life, the photograph opposite thankfully at last shows a living Lepidopteran — but only just! Its apparent rigor mortis is, in fact, torpor as the image shows a hibernating peacock butterfly.

In the crumbling hulk of a collapsed corregated-iron cowshed, I saw a rusted sheet, back-lit with brilliant golden sunlight. It looked like a computer-generated outline of the Greek coastline. It had a graphic look and its 'lands' of rich red dust reminded me of Ayers Rock at sunset. Visually, it was very appealing, a photograph begging to be composed.

Meanwhile, hibernating in the folds of my parents' corrugated-iron garage roof, as they frequently do, were four peacock butterflies. About 10 miles separated the two subjects, but an eternity separated the photograph. How many decrepit cattlesheds or garages would I need to visit to find the two perfectly placed together? Far too many — so I re-created the two elements

**Peacock butterfly on rusted iron**
*Canon A-1, 50mm lens, tripod with cable release, Ektachrome 160 Tungsten*

100

together to produce a contrived, but realistic-looking, result. The dark brown undersides and jagged edges of the peacock's wings complemented the tones and textures of the old iron perfectly, so I backlit the scene with a couple of anglepoise lights in front of a black curtain, and used a torch to top-light the insect from behind the metal sheet. In many of the frames I shot, the insect was almost inseparable from its metal mainland; but by gently coaxing it into the top light I was able to highlight its wings without producing any colour. I found that using the backlight to illuminate the insect showed up its distinctive peacock eyespots and made it more immediately identifiable and less abstract.

Peacock butterflies make ideal subjects for your first Lepidopteran snaps. They are common, large enough to fill the frame easily, and tolerate even the clumsiest approach, especially if they are at some nectar-rich bloom. They are, however, quite dark underneath; even their upper wings are not really bright, so take care with exposure if they are feeding on brilliant flowers.

## Lager lout

BUS-STOP BOREDOM drew my attention to the brilliant reds and yellows of a billboard poster that had been prematurely ripped from its hoardings by the local wing of the anti-alcohol league. Australian lager was obviously a prime target for these vandals, more probably due to the copious volume of the stuff they had already consumed, than to a true objection to its advertisement. Anyway, capitalizing on the misfortune of Castlemaine, I rolled up several sheets of the torn paper and later laid it over my lawn.

**Peacock butterfly on torn poster**
*Canon F-1N, 100mm macro lens, tripod with cable release, Ektachrome 100 Professional*

Knowing that the buddleia bush can frequently be found growing on the strips of wasteland in front of billboards or from the bricks in the wall that support them, and that the rich nectar supply of its flowers regularly attracts an abundance of peacock butterflies, I planned my picture from the privacy of my patio. Of course, I could have rung Castlemaine to find out who stuck their bills, rung the bill-stickers for a current map of sites, driven around Britain until I found one near some buddleia and waited, perhaps spraying the poster with some sugar solution to attract the insects. But no, I caught the best condition peacock I could swipe over next door's fence as it hovered above their blooming bush and put it on my fragment of reality. The shot opposite is OK but I wish I had pasted the poster onto a piece of flat board first, as I don't like its undulations. I also wish that I had used my diffuser board to reduce the contrast of the butterfly on its bright white perch.

# THE ETHICS

TWO ETHICAL CONSIDERATIONS are confronted by this photograph. Firstly and most importantly the capture, handling and containment of wild animals for photographic ends. The trouble is that there are no rules. Legal documents like the Wildlife and Countryside Act seek to protect our rarer species but do little to influence the way we treat the majority. The RSPCA copes with the large 'furries and featheries' very well, but rarely receives calls to intervene in cockroach massacres or arachnicides. In general, invertebrates get a rough deal. How many readers would object to pushing a fly into a spider's web to photograph a carnivore at its lunch? How many would be repulsed by a tethered starling waiting to be munched by a fox, or a cat tied out for an eagle, or a deer staked out for a tiger? You see — where is the line drawn?

We each pick up the pencil and draw it ourselves. I am a great lover of invertebrates and would never have allowed my brimstones to 'escape' unless my garden was not just a few metres from some suitable habitat. Indeed, with many species of spider, bug, beetle and fly, I have driven miles to release them exactly where I caught them, something that many of you may consider quite mad. We each have to set our own personal code of practice, quite apart from anything that could be legally defined as cruelty or ecological or behavioral disruption. Borrowing brimstones is okay by me but may be too much for you. I'll respect your view and, so long as no harm comes to the subject, be happy to argue my case.

Secondly, should wildlife photographs be taken entirely in the wild, with no such combination or contrivances? Many would say yes, forsake your artistic aims and accept reality with all its imperfections, all of its protruding twigs, lack of composition, distracting images etc., because this approach captures the reality of pure wildness. For some, the agony of searching for or waiting for what I would only describe as a useful seed of an idea, makes a photograph something to be hallowed. But frostbite, gangrene, swarms of mosquitos, interminable waits in uncomfortable hides or hundreds of failed frames have never turned a photograph into a picture. Great Art is not always achieved through suffering, or struggle or expense. If you can produce great art in your own garden, then why go to the Serengeti? If you can predict how a species will behave in a particular situation or at a certain time of the year, why wait for days on the offchance that you will see something interesting? If you can orchestrate reality to produce a better result with no detriment to the subject, your health or your bank balance, then do it. If you do not agree with me then fine, but don't expect any praise for the tales of woe behind your photographs because they have to stand on their own, in absolute silence, and they have to be very good to make the quantum leap from snapshot to picture.

# Flintstones

MARBLED WHITES are chalkland butterflies — need I say more? Only that this particular shot was taken in the field because if such a species were to escape into urban Southampton it would almost certainly perish before it found any suitable habitat. A tray full of flints and chalk fragments from a nearby road cutting, laboriously carried up a bridleway to a local downland reserve, laid beneath my patent diffuser board and garnished with one of innumerable marbled whites produced the desired results. A touch blue, an 81A or B filter would have warmed up the whites a bit, but otherwise suitably half abstract.

# Living lantern

THE NEXT 'COMBINATION' overleaf was altogether more adventurous, more difficult to achieve and more spectacular. Detaching a torpid butterfly from the garage roof one freezing January night with a soft paintbrush is altogether easier than asking an active specimen to roost on some dew-drenched grass in full morning sunshine. In fact, no less than five male brimstones were asked to star and only one interpreted the role correctly for a few moments.

Again the photograph was composed in my imagination from two widely separated images. Whilst cutting and burning pine saplings to preserve sunny spots for nesting sand lizards, I saw a few large clumps of *Arrhenatherum* grass backlit and festooned with dew like a sparkling firework. The image was striking but the surroundings entirely unsuitable for a photograph. The background was confusing, the grass stems lost against a pale sandy path and there was no subject available that particular autumn morning. The following April on a piece of local wasteland I noticed a freshly emerged male brimstone caught by a stray ray of sunlight burning like a little sulphur lantern in the top of a bramble bush. I hurriedly assembled my camera but despite furtive probing and poking could not find a picture through my lens. There was always something wrong — a stray twig, flare down the lens, an out-of-focus white leaf behind it competing in the frame, etc. Then I remembered the grass fireworks and the two images combined in my mind, leaving me the relatively easy task of creating the reality.

I collected a bouquet of the grass and planted it in a brick of flower arranger's 'oasis' on the seat of an old chair, hung a black cloth over the garden fence, filled my plant mister and, as the sun rose, moved my set into a prime position and misted to make sparkles at every tip. The sun was already strong enough to rapidly evaporate each little jewel, so re-misting was continually necessary. I looked at my set from all angles, decided on the best, and checked my watch. That evening I went to the woods with my net and caught a few male brimstones. Keeping only the smartest five, all placed in separate containers, I returned and left them under a darkened cloth on a shaded shelf in the garage ready for the following morning.

The rest is obvious. After three of the butterflies who didn't like my sparkling stage had been 'released', one deigned to hang for a minute or so, even allowing me to mist him gently as well as the grass and get one of my favourite early photographs.

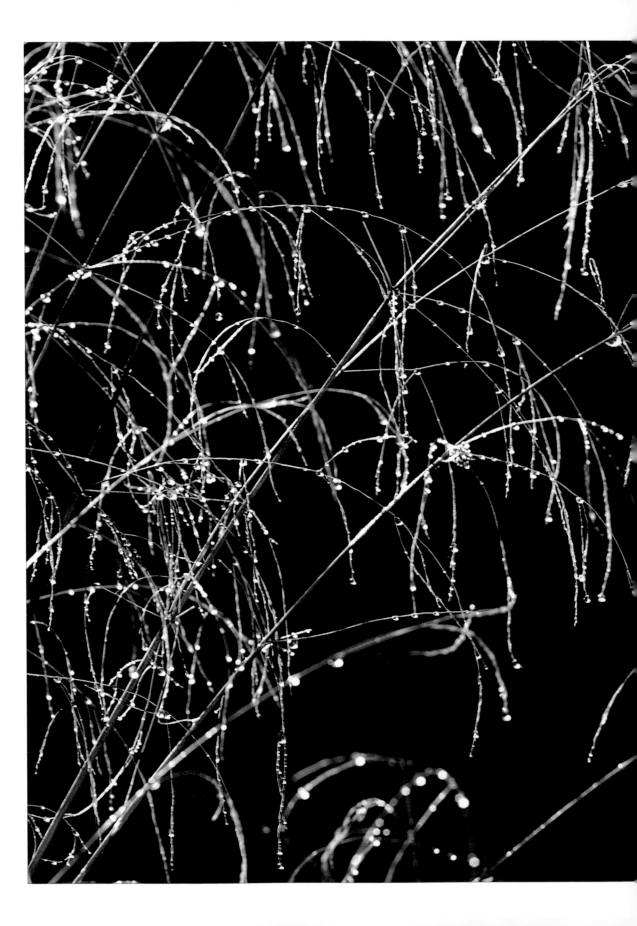

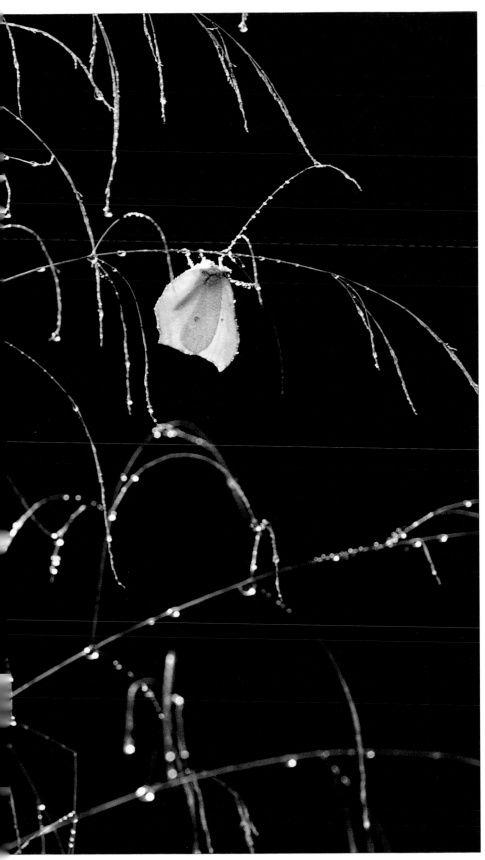

**Male brimstone
butterfly on
*Arrhenatherum* grass**
*Canon A-1 with 70–210mm
zoom lens,
tripod with cable
release, Kodachrome 64*

# Human Lenses

THE HUMAN EYE is an extraordinarily versatile and acute organ. It is not the best in nature: imagine how your perception of the world would be through the eyes of an eagle or vulture or those of an owl at night. These birds cannot see any further than us, nor do they perceived magnified images; what they see is a much sharper picture of the world they look at. Some owls have 14 times as many light-sensitive cells than us in the same area on their retina and because of their nervous arrangement can effectively see with a clarity greater than 14 times better than ours.

Despite their crudity, cameras actually produce an image which may have more in common with eagles than with human eyes. Consider a photograph of a bird on a lawn. Given that it technically tends to perfection, each blade of grass within the field of focus will be sharp, as will all of the subject. Now look at a bird on a lawn unaided by binoculars or telephoto lenses and imagine you see it for $1/125$ of a second. You do not see every blade of grass, just green lawn with little detail; nor do you see any detail in the bird, but rather a recognizable shape and colour and some key features, such as long or short legs and a particular beak shape. In the photograph it is all there to be taken in, not in $1/125$ of a second but for as long as you wish to study it.

What I have tried to do in the following photographs is to reproduce what I see when I look at these insects with my own eyes, rather than through a very expensive macro lens. The results are often impressionistic but, to my mind, far closer to the reality of the experience.

## Bubblegum vampire

THOMISUS ONUSTUS doesn't have a common name although I've always called them Pink Crab Spiders (PCS). Their very long forelimbs prevent any forward gait and thus they clumsily shuffle sideways like crabs. From June to September you can try and find these fabulous candy killers on our southern heaths where they live on the flowers of the crossed-leaved heath. They are a triumph of crypsis, matching perfectly the colour of the flowers, and their blotched white legs, stripy carapace and peculiar triangular opisthoma (abdomen) make them almost impossible to find. This extraordinary camouflage serves two functions. Firstly it renders them invisible to birds such as Dartford warblers, stonechats and pipits, who spend their summers scouring heathland's rich spider fauna for nestfulls of hungry youngsters, and secondly it hides the spiders from their potential prey — bumblebees.

At a maximum of 8mm long, female PCSs are no Amazons able to wrestle with their larger adversaries. Instead they play the part of a vampish assassin, leading their victims in a dance to their deaths. In jerky steps they arch their open forelegs around a bee which has arrived to sip nectar from the flowers. They patiently and precisely tickle it until they align head to head and finally they strike. There is no bloody battle where the brute strength of the bee could play an ace hand, because it is paralysed or dead within three seconds

**Pink crab spider (*Thomisus onustus*) on clump of cross-leaved heath**
*Canon F-1N, 100mm macro lens with 50mm extension tube, tripod with cable release, 2 softener filters, Kodachrome 64*

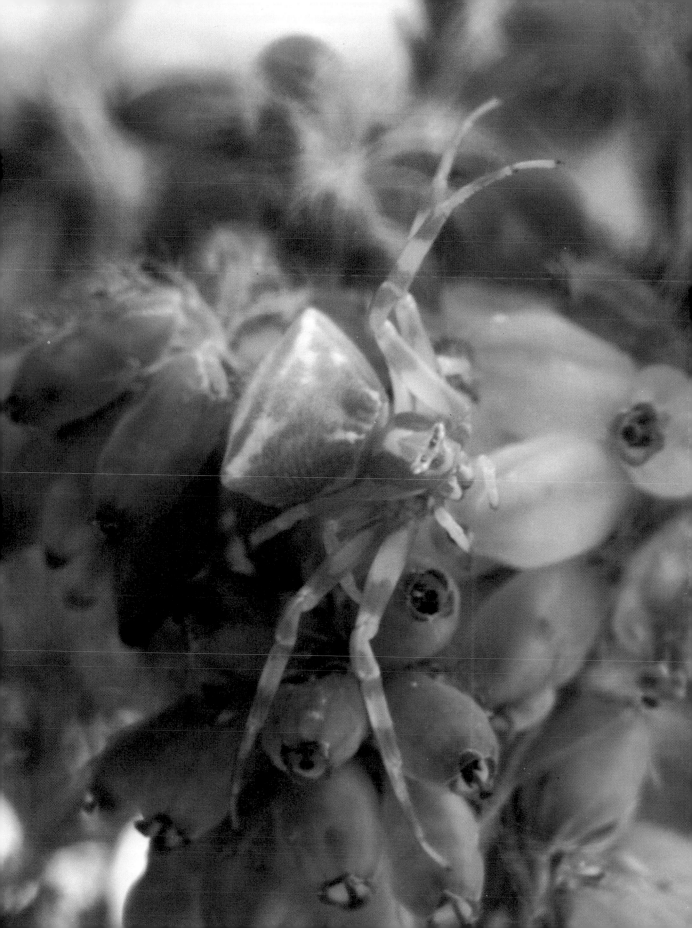

of the stab of the spider's fangs. The bubblegum vampire then hangs her victim down as she sucks it dry and in a few hours the bee is no more than a dried husk blowing away on a coconut breeze between the gorse. The spider's shrivelled, pink sunburned skin swells full of bee's flesh and she sits there and waits for another, perfectly still, perfectly pink, very pretty and ever so deadly.

Right, now down to business. First, find your crab spider. There is only one technique. It involves knee-snapping, back-breaking, eye-bursting and brain-numbing delirium as you crawl from clump to clump of cross-leaved heath and search each individual flower head in turn. See how many you can check before you begin to relate to mad dogs and Englishmen. But here's a top tip — look for any accumulations of dead bees. On sunny days bees buzz furiously from flower to flower, hardly pausing in their frenzied search for nectar. If one is not moving it actually sticks out like a sore thumb and signals its presence. It is either a lazy outcast (highly unlikely) or more likely a victim of the PCS.

I photographed this female on a clump of flowers augmented by sellotaping a few extra heads together and, to enhance its crypsis and make it look more as we see it and not how a very expensive pin-sharp macro lens on a camera sees it. I added a couple of soft focus filters. There is another shot where I used a third softener and huffed on the lens as well, but my girlfriend says it is not sharp and she cannot see what it is — much more like the real thing I would say!

## CHILLING INSECTS—THE ETHICS AND PRACTICE

I HAVE ALREADY mentioned the contentious nature of manipulating wild subjects for our photographic ends but here push the controversy to its limit. After personal debate and consideration I include this brief passage on the chilling of insects on the premiss that many of you will have heard of the practice and that an accurate guide to its implementation will prove more beneficial to all those butterflies that could otherwise be frozen by ignorance. Of course, there are insect photographers who work entirely in the wild; but I would guess that there is not a single professional photographer or film-maker who has not used this technique at some time or other to facilitate a shot. However, I have never before seen any published guidelines and as a result I am sure countless insects perish.

The basic idea is obvious. Insects, being cold-blooded animals, require a threshold temperature to metabolize enough to move. By reducing their body temperature close to this threshold, you can restrict their movement for long enough to get a shot without them scuttling, jumping or flying away. In the shade of a leaf on a cold spring night, the temperature may hover a few degrees above freezing whilst in a sheltered sunspot only hours later it could near 30°C. Consequently insects have the physiological ability to cope with such extremes. While it is both unethical and dangerous to explore the extremes, reducing their body temperature by a few degrees is well within the bounds of their daily routine. Even within the cold-blooded orders, however, only some insects operate over a range of temperatures which permits this approach. Butterflies and moths generally respond well, as do honey bees and bumble bees. Wasps, however, both social and solitary, can be damaged, whilst hornets will be destroyed by any attempts to chill them. Grasshoppers walk more slowly but their remarkable leg muscles still fire them into orbit with the same force and frequency. Large beetles slow down, but

# Death cone

THE PCS is not the only CS to live in Britain. There are in fact two more, the commonest of which is *Misumena vatia*, the white crab spider — although the name is misleading as it can actually vary in colour from white to pale green or even a bright canary yellow. Needless to say, it frequents colour-matching flowers, the white version favouring umbelifers such as cow parsley or hogweed. From May or early June onwards, beating a hedgerow of these plants over an open umbrella will generally provide a WCS or two. Their bodies are more rounded than that of the PCS and often have red spots or stripes. (Males of both species are smaller, longer-legged, shrivelled, boring brown jobs of no photographic merit.)

I chose to put the female pictured overleaf into the conical trumpet of a common bindweed bloom, indoors, to prevent any irritating wind vibration. As these spiders have fragile legs and relatively heavy bodies, always take the precaution of placing cushioning material beneath your set because one of their escape ploys is simply to let go and fall into the safety of the undergrowth below. In the field this necessitates a plastic sheet under the spider as trying to tease one up from tangled heather or grass is not only frustrating but potentially amputating for the subject. Pulling legs off spiders is best left to horrible infants.

I like to think the photograph has potential, although I now wish I had used a mirror to reflect some light under the flower to even the shading of its petalled sculpturing, making it more white and more abstract. I offer my

medium or small animals remain unaffected. Dragonflies are strictly out. The practice is useless for warm-blooded animals as they will adjust their metabolism to maintain a working temperature.

You must use the fridge, not the freezer. I cannot give you time or temperature guidelines: these vary depending on the species, its acclimatization to previous conditions, the outside temperature and a host of other invisible immeasurable factors. There is, however, one golden rule: *never, ever leave the fridge*. Don't answer the telephone or the door, feed the cat, make a cup of tea, check your camera or watch television. Place the insects in individual transparent plastic tubs, sit on the floor alone and every few seconds open the fridge door and assess the condition of your subject. It may take a minute, it may take five, but as soon as the animal shows signs of torpor take it out and transfer it to its perch with a soft paintbrush. The insect should be able to stand properly, and should reach its 'go' temperature within a few beats of its wings and pumps of its abdomen. If this is not the case, then you have over-chilled it, and you must modify your practice permanently and effectively. You will have seconds with your subject, so use them well.

Use your common sense. Do not chill a butterfly to 5°C and then stick it out in bright midday sun, as the temperature difference could prove fatal. Try to use overcast days, and do not repeatedly re-chill the same animal as this is debilitating. Remove any traces of condensation from your container to prevent the subject sticking to its sides.

I am not being economical with the truth when I say that I have never had a fatality on my hands using this practice. I was well tutored, however, and have never let my respect for the subject be overruled by my desire to produce a successful photograph. If you wish to try this technique I suggest you find a photographer honest enough to admit that he does it and then hammer him for tips. Do not accept trial and error as a *modus operandi*, because error in this instance is quite unacceptable.

**White crab spider (*Misumena vatia*) on common bindweed**
*Canon F-1N, 100mm macro lens with 50mm extension tube, tripod with cable release, Kodachrome 64*

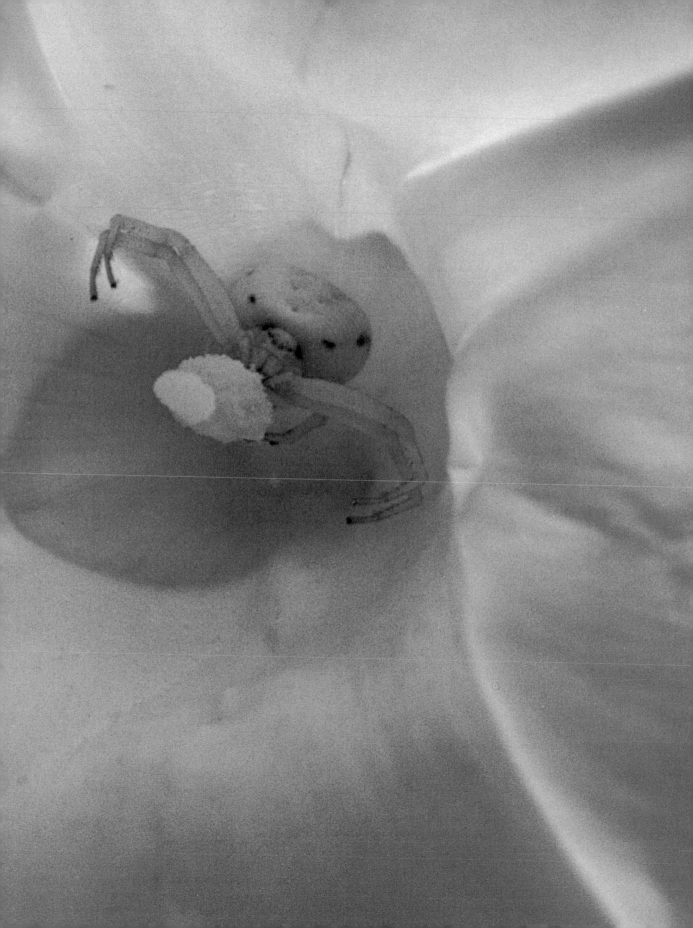

usual excuse; it was taken in 1984 when I had only been taking pictures for eight months and I have never had time to repeat the effort. Also, the photo is not absolutely sharp — despite a good depth of field, no diffusion, flare or cheapo lenses. This may be because the tripod was set up on carpet and despite my standing still in case of any wobbly floorboard effect, a little camera shake has resulted from the vibration of the mirror lifting and the shutter firing in the camera. Since I realized this I have always stood the tripod on a square of chipboard when shooting indoors. Just a thought!

## A green scene

ANOTHER PHOTOGRAPH that I took indoors was this portrait of a great green bush cricket, one of Britain's most monstrous insects. Britain is somewhat starved of grasshoppers and crickets because of their need for warm dry summers, so it is only in the south of England that about forty species can be found. Of these, the greenest and greatest and, without doubt, the noisiest is this splendid fellow. Forget Pavarotti, forget Guns and Roses; at 1 metre on a still evening this raucous songster will blow you away with an unending burst of feedback beyond the scope of any synthesizer. The Jesus and Mary Chain are its only comparison but they are too tuneful! Shrubby hedgerows, with nettles, brambles and its favourite thistles (south of the Wash) are its typical habitat. Despite their large size (their wings can reach 7cm long) and loud voice, which can be heard from 600 metres away, they can be remarkably difficult to see even when you are within centimetres of them. Their straggly shape and a browny-black stripe down their backs render their motionless bodies invisible in the vegetation, and if you probe about and disturb them, they will pull the plug and you'll never find them. They are easily caught by hand but take care because they do bite. The best method is to grip both back legs firmly. Also, cannibalism can result if they are kept together, so the rule is: singles only in captivity and make sure to give them plenty to drink since they always seem thirsty.

A set of sturdy grasses and reeds stuck onto a slab of oasis is all you will need, although once you have arranged it through your lens it is best to trim off the tops to prevent any weighty waverings of the lower stems. Next, add your subject and coax him into the right spot with a soft brush. It sounds simple, but it won't be; so be patient and be prepared to have several attempts at it, perhaps even spread over a few days, resting the insect in between. You may need to water your grass on this account.

Another useful tip is to tape your oasis to a flat board or tray so that you can slide the set and the subject into focus rather than shuffle your camera and tripod clumsily backwards and forwards. This technique is often of great use when photographing macro subjects as you will be working with very little depth of field.

I added a slice of Cokin mega green gel here to enhance the greenness of the 'Great greeny' but really I overdid it and wish I had used a sprig of grass as a makeshift filter to produce some out-of-focus vignetting and make the shot more naturally green.

**Great green bush cricket on grass stems**
*Canon F1-N, 100mm macro lens, tripod with cable release, Cokin green gel, Ektachrome 100 Professional*

114

## Grass stars

FEMALE GLOW-WORMS actually generate their own light from light-producing organs, specially adapted to house a chemical reaction that is controlled by water and oxygen, and a reflective layer beams this out of their abdomens as a highly specialized show of sexual attraction. This illuminating system has evolved because these wingless, and thus flightless, females need to be found by the more typically beetle-looking airborne males. The lightless males, in turn, have huge eyes for spotting the neon nymphos in the grass below, but if the females are disturbed by anything more than amorous advances they cut the oxygen supply and switch off into the safety of darkness.

As a photographic subject, the grassland species of glow-worm can prove difficult. Indeed, when I took the photograph opposite I had never seen anything comparable (big head!). The reason for this is simple. Photography relies heavily on the transmission of light onto the film to produce an image and, as you know, a relatively large amount of light is needed for anything to register. Glow-worms, on the other hand, do not like large amounts of light. The females emerge at night to glow and immediately switch off if things get brighter. Their own illumination is never bright enough to photograph them by, and if you shine light on them they stop glowing and look like ugly little brown bugs, nothing like the flickering grass stars from fairytales.

The problem was easily solved. Firstly, if light is such a turn-off for these beetles, then turning them into silhouettes seemed an obvious answer. All I had to do was to match the level of light in the background to the level of light that they produce in the last three segments of their abdomen. Old grasslands are their favoured habitat so I collected a few glimmering specimens one chilly June evening. They refused to glow on my indoor set that night, so I tried again the next evening on the patio. Success! They soon struck up a pyrotechnic display and I got a half-hearted reading from my spot meter whilst I fumbled around in total darkness. Next I pinned a dark blue bath towel to the wall as a background and placed a couple of 100-watt anglepoise lamps on a table opposite. I then chivvied a couple of these living lanterns up some grass stalks set in a block of 'oasis', waited until they hit full power before switching my lights on (producing my own 200-watt moonbeam) and managed to snap away for a few seconds before the insects switched off their 'sex-for-sale' neons. I moved my own lights back and forth to make the background lighter and darker and patiently repeated this procedure over an hour or so. I bracketed wildly and shot a whole role of Ektachrome 160 Tungsten, often on long exposures of one or two seconds, but got the result I needed on about 4 frames, of which this had the most pleasing composition.

**Female glow-worm**
*Canon F1-N, 100mm macro lens with 50mm extension tube,*
*tripod with cable release, Ektachrome 160 Tungsten*

# PLANTS

Until the age of sixteen the only plants that interested me were triffids! John Wyndham's mobile, socially organized and dangerous species sadly upstaged all real-life flora and, despite my obsessions with other orders of the Animal Kingdom, the green bits somehow failed to blossom, unless you count a romantic fling with a yew tree in Selborne churchyard which I imagined provided wood for our longbowmen at Agincourt.

Of course as soon as my ecological education reached the concept of food chains and nutrient and mineral cycling, I realized the importance of plants; my attention was drawn to this static, green group with its confused sexualities and bewildering array of species. In order to make up for my years of ignorance I teamed up with a good botanist, my friend Andrew Welch, and buried myself in a glut of identification and plant ecology. Emerging from this a couple of years later I became infatuated by the glossiest of our greens, the orchids, and embarked on innumerable madcap journeys to find, fondle and photograph all British species of this group. Several remain unglimpsed but I pursue them with unabated ardour. To be honest, such a single-minded obsession with glamour is fairly shallow and I have since expanded my interest to cover nearly all of the botanical spectrum—with the exception of pond weeds, plankton and faecal algae!

Photographing plants well can be difficult. They are rooted and immobile and thus most of the work needs to be done in the field where you are at the mercy of the elements and prevailing light and stuck with whatever surroundings and natural backgrounds happen to be there. As you can imagine, such restrictions do not endear themselves to me and I have developed various methods of overcoming weather conditions and horrid backdrops; these are outlined later on in this chapter. Flowers, the reproductive parts of plants, normally have an aesthetic appeal and so I include a few simple portraits, but isolating these organs to the detriment of the plant as a whole is slightly artificial and for this reason I have included shots of leaves, trunks, twigs and a few extreme abstracts. Fungi (although they are not plants) also appear here.

## Portraits of flowers

Like preening peacocks, flowers beckon and seduce. They are most often the showy bits of plants, the attention grabbers, gaudily coloured, extravagantly marked and heavy with scent. But all this razzmatazz is certainly not for our photographic benefit. Flowers are the business end of the plant. They are the

**Poppy**
*Canon A-1, 100mm macro lens, 50mm extension tube, tripod with cable release, Kodachrome 64*

118

way they are simply because they have evolved to ensure that they attract the right pollinator, that the pollen is transferred successfully from the anthers of one flower to the stigma of the appropriate recipient, that seed is set and finally released. It is interesting that in plant species that rely on the wind to pollinate, much more pollen tends to be produced (the wind is a bit hit and miss) but the flowers are often less showy.

## Heartburst

A BLOOD-RED HAEMORRHAGE was my aim for the portrait of a poppy on the previous page. What could be redder than this common annual's petals? In my photograph, even the black budding seed capsule and its ring of stamens is rendered red. A dead still day, a garden cane and some wire ties to fix its weak wavering stem, a mirror to reflect some light up under its skirt and a 100mm macro lens coupled to a 50mm extension tube to get right in where the action is were all that was required. Again Kodachrome has faithfully reproduced the colour, but to enhance its full saturation I bracketed the shot, underexposing by half a stop and then a full stop. I think most flowers look better a little underexposed.

## Where the bee sucks

THE WILD GLADIOLI is a serious vamp, a Monroe of a flower that is as rare as it is alluring. If I were a bee then this would be my ultimate nectar source. Its magenta petals, bright purple pennants advertising sugar sweeter than sweet, positively glow in the shade of bracken when it appears in early July. Chauvinism aside, we must not forget that all flowers are sex objects, hermaphrodites mostly, but with one purpose in mind—pollination; and the ones which we humans find most attractive are those that advertise their wares most conspicuously—the real tarts!

The wild gladioli is not a vulgar version of the gaudy garden varieties; it is a smaller bulbed perennial which was not even discovered in Britain until 1856. It remains rare and is limited to an alleged 35 populations in the New Forest, although I have seen only four or five, and I suspect that it may have disappeared from the majority of the remainder. Public pressure is the cause of its demise, nothing more than picking. Indeed, despite its legal protection, I have seen small bunches of 'gladdies' being brandished by middle-aged female vandals!

The plant in the photograph opposite was a monster. About 40 centimetres tall, it was armed with eight huge flowers, five of which were fully opened when I took the shot. I had just one aim in mind, to record an impression of that colour, because, whilst the petals are beautifully twisted, curved and shaped, it is the shocking magenta that shouts from the shade.

The magenta/mauve colour of the wild gladioli has been reproduced pretty well by my choice of Kodachrome, a film renowned for its red-reproducing qualities, and thus required no colour correction. I did use some filters, though—two softeners to destroy the sharpness and concentrate more attention on the flower colour alone.

**Wild gladioli**
*Canon F-1N, 100mm macro lens, tripod with cable release, two softener filters, Kodachrome 64*

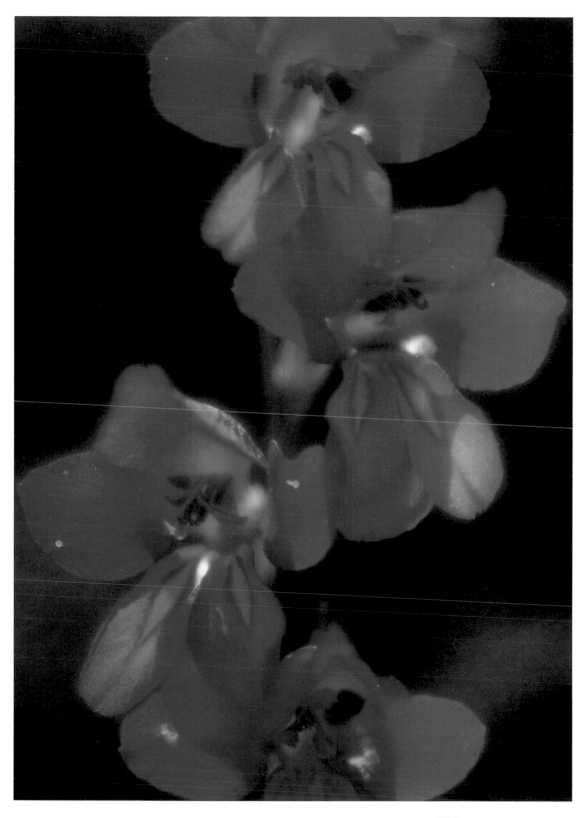

# Supernova

I HAVE ALWAYS liked those misty photographs in astronomy books of distant nebulae, swirling masses of space gases in purples, reds and golds, and all those sparkling twisted galaxies, like far-out Catherine wheels spinning slowly in infinity. Lying on my lawn one post-pub Saturday afternoon I noticed a similarity with the common dandelion—a supernova in your own garden.

Dandelions are members of the largest family of flowering plants, the Compositae, which are typified by having very small flowers (florets) clustered together in heads (capitula), which in turn are surrounded by green leafy bracts. The florets are of two main types—tubular, normally found in the centre part of the head, and ligulate, a more petalled form found around the outside of the composite flower. Other typical species of this family are thistles and daisies.

Dandelions are a hopelessly complicated group. All of the British species are regularly apomictic—that is to say, they seed without any fertilization because their pollen is defective. About 200 so-called 'micro species' have been described in Britain, and in order to identify any one fully you will have to consult a complicated series of botanical keys. I have never bothered as I am content to count them amongst my favourite plants on the strengths of their aesthetics, not genetics!

To mimic my vision of a distant galaxy I draped a matt black twill cloth over the back of a chair so that it touched the ground and set my camera on a bean bag facing the flower in profile. (Black velvet is an ideal backdrop cloth as it is non-reflective and has no obvious weave. It does attract fluff, though—so I go for coarse cotton twill which is easier to clean.) I then scissored away all of the grass that interfered with the golden disc and cut a small hole in the centre of a large piece of black card through which a ray of bright sunshine lit the 'lion's teeth'. Bean bags and scissors are two of a plant

## FILTERS AND FILMS

LIGHT IS a beautiful yet peculiar phenomenon. Sadly we can only see a tiny fraction of the spectrum—wavelengths between 0.4 and 0.7 of a micrometre, which correspond to violet and red light. Between X-rays and radiowaves there is a whole dimension which is invisible to us—although not to all animals.

Due to the limitations of photographic film, recording plant colour accurately can be a real problem. Film manufacturers struggle to give film a balanced sensitivity to all of the spectrum which we can see, but none successfully catches the rainbow. Flesh tones, sky blues, grass greens and sunshine yellows are all generally recorded well, but more unusual mixes of colour are reproduced less accurately. For instance, many films are sensitive to reflections in the red and infra-red part

of the spectrum where our eyes have no such sensitivy. The film sees what we cannot, and because some plant's deliberately use these wavelengths of light to attract insects, our photographs prove disappointing—although they'd probably get a bee buzzing!

If you are using print film, then you can correct colour to a certain extent by altering the density of the filtration in the printing stage, but with transparency film there is no printing stage and your colours are fixed for ever.

The only way to overcome this problem is to experiment with different films and filters. Blue flowers seem to be the worst offenders and the simple solution is to add more blue to lessen their photographic pinkness. To turn pinkbells into bluebells, simply add an 85c filter!

photographer's basic necessities! Gardening—that is, the clipping away of unsightly fronds—should be done judiciously, however, since delivering a short back and sides to a patch of turf is a little immoral and often destroys the micro habitat of your subject.

I was quite pleased with my floral galaxy. The ring of exploding yellow florets glowing so brilliantly in the shade of suburbia has made a striking portrait of one of our most familiar species—whichever one of the 200 it is!

**Dandelion**
*Canon A-1, 100mm macro lens, bean bag and cable release, Kodachrome 64*

The true purist can run exacting tests using film of a known batch to photograph a Kodak colour separation chart (a bit like a TV testcard) with a range of colour correction filters. By standardizing conditions you may come close with some species, but the hues of others will remain elusive because films just will not cope. For most of us, just keeping bluebells blue with a gentle blue gel will suffice. If you can be bothered to bracket a few shots with a selection of gels, you may save a few more blue or violet blooms from spectral oblivion.

Get to know how particular makes of film react in different circumstances. You may have noticed that all my pictures have been taken using Kodak film because when I was beginning to take photographs, there was a rumour amongst my peers that *National Geographic* magazine preferred all its photographers to use Kodachrome 64.

I found Agfa film a trifle yellow or orange, and Fuji to have a greenish tinge (indeed, I used to joke that the colour of the cardboard box was related to the colour reproduction of the film). To be fair, I found Ektachrome too blue for my liking and only used it accompanied by an 81b filter to warm it up a little. It is all a matter of personal taste: each film type has its followers. The important thing is to experiment to find out what you prefer and then stick with that film enough to fully understand its capabilities. You will quickly learn how it behaves in all sorts of light, how it reproduces colour, how much you need to under- or overexpose it for effect, how it is affected by slow shutter speed and how it behaves with your choice of filters. Often you may have toiled to be in a position to paint your photograph so it is best not to arrive equipped with an unknown palette.

# Ladies-in-waiting

THIS PORTRAIT of two marsh helleborine flowers was taken on a roadside verge in Dorset and shows our most tropical-looking orchid. Up to ten flowers are arranged in loose clusters on each stalk and whilst a verge full of nodding 'hellies' is quite a sight you need to drop to your knees and look at a single bloom to appreciate its exotic nature. The flower is divided into an outer whorl (the three sepals) and an inner whorl (the three petals), of which the middle, or labellum, is the most exciting. This lipped structure is composed of the inner hypochile and outer epichile which is beautifully curly and joined to the former by a flexible bridge. A whole range of effective pollinators— bees, wasps, flies, beetles and even ants—seek nectar in this luscious grotto. The larger of these can often be seen with pollenia, the orchid's sticky sacks of pollen, glued to their heads ready to rub against the stigmatic surface of the next flower they visit.

Marsh helleborines can be found all over the British Isles, but they favour marshes, dune slacks, fens, wet sandy soils, or even newly exposed ground in gravel pits and building sites. Sadly, relentless drainage has reduced their

**Marsh helleborines**
*Canon A-1, 100mm macro lens, bean bag and cable release, softener filter, Kodachrome 64*

range, but if you refer to your local flora or ask at your local naturalists' society there is sure to be someone who knows a site and will probably disclose it. Many other British orchids and helleborines are very rare and their whereabouts are consequently shrouded in secrecy. You will have to graduate to these along the orchidophile grapevine!

For the shot opposite I used my bean bag to position my camera a few centimetres above the tarmac and used a black backcloth to plunge the background into shade. I tried various combinations of softening filters. These produced a very pleasing effect of out-of-focus green fronds, but also irritating halos around my two flowers. This shot has only a slight softener to add to the glamour of these stars.

## Magic lantern

THE SHOT of harebells overleaf was taken using my wind tent on a Scottish roadside and illustrates a creative approach to image destruction. Two soft-focus filters and some vaseline prevented any sharpness creeping in, a blue correction filter has almost saved the delicate hue of these common grassland flowers, but not quite as the hint of pinky turquoise reveals, and the rear cellophane sheet has produced a bizarre background. As a result, the flowers have become objects of light rather than structured, mechanical organs; the confusion of the halos and streaks makes them much more photographic than the preceding portraits.

---

# THE DO'S AND DON'TS OF PHOTOGRAPHING RARE PLANTS

JUST AS WITH BIRDS there is a schedule of plant species which are afforded special protection under the Wildlife and Countryside Act of 1981. Many of those listed are very rare but, dare I say it, also photographically challenged. You will not want to wave your lenses at oblong woodsia, but the likes of wild gladiolus, ghost, monkey, military and lady's slipper orchids or snowdon lily may excite your trembling shutters. Fortunately many of these luscious exotics are also regularly wardened throughout their flowering periods, often 24 hours a day, so no deviants can pluck them. When you discover the whereabouts of these sites—they are not freely advertised—you should arrive prepared to photograph a 'show plant', generally on the edge of any colony to prevent unnecessary trampling, which is made available for all and sundry to study and photograph. You will have to be content with this.

If it has really withered, try bribing the warden! He or she has probably been slumming it in a grotty caravan for months on their own. A few tins of lager, some ice-cream, designer soap and talcum powder and a copy of the latest *Playboy* or *-girl* have actually done the trick for me at one time or another. No level is too low for the professional who needs success!

Humour and immorality aside, you must play by the rules. Stick to the paths, do not chomp down acres of interfering herbs when the warden's back is turned, always leave a healthy donation in the tin (tip the warden, too) and then move on.

Please act responsibly at all times: no excessive gardening—a plant's microhabitat is often crucial to its survival—and be careful where you tread, lie or set your tripod because many species of orchid produce almost invisible non-flowering spikes which will be critical for next year's blooming. As with all rare plants and animals, do not draw attention to your subject's location; although you may respect and revere it, there are others who would pick it in ignorance. Remember that every last species of British wildflower is protected and cannot be picked by unauthorized persons.

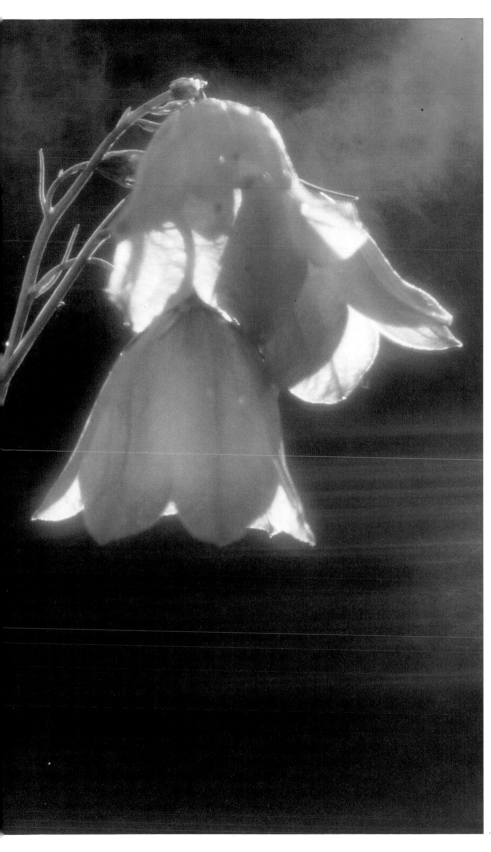

**Harebells**
*Canon A-1, 70–210mm zoom lens, bean bag and cable release, wind tent, 2 softener filters, 1 blue filter, Vaseline, cable release, Kodachrome 64*

127

## Grass of Parnassus

**Grass of Parnassus
flowers**
*Canon A-1, 100mm
macro lens, 50mm
extension tube, tripod
with cable release, 2
softener filters,
Kodachrome 64*

IN THE WILD, as a result of the same excessive drainage that has afflicted and constricted the marsh helleborine, grass of Parnassus is now much more numerous through northern England, Scotland and Ireland than in the south. It favours marshes, wet pastures, moorland flushes, although once I found a great abundance on the dune slacks on Newborough Warren at Anglesea. The main time to look out for its flowers is between July and September.

This shot, however, is of potted specimens photographed indoors against a black background. My aim was to concentrate attention on the luminosity of these fabulously constructed little flowers, with their frilled, wavy stamens and thickly veined petals.

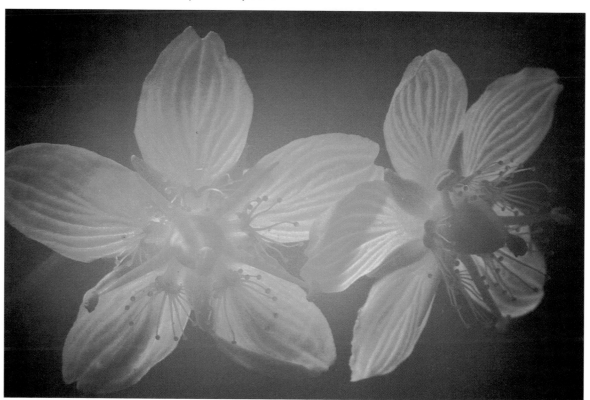

Using the same sheet of stout cardboard that I had used for the dandelion shot on page 123 (never throw away props, I still have this today!), I shone an anglepoise lamp on the plant, having first sellotaped tracing paper over the head of the lamp to diffuse and soften the light. I further softened the image by using two softener filters and huffing on the lens. By overlighting and then underexposing through this fog, I have managed to make the petals flare a little and appear to have their own radiance. Artificial yes, but certainly an attractive enhancement of these pretty little plants.

## Pretty pictures

THE FOLLOWING TWO PORTRAITS are no more than average snaps of a couple of super species. The first shows the rare military orchid. The individual flowers

# AIDS TO PLANT PHOTOGRAPHY

Working out in the field you'll often feel that the elements are conspiring against you. Usually, such thoughts are irrational and could be the product of a disturbed personality. There are a few handy do-it-yourself constructions, however, that could significantly increase your photographic success rate while helping you hold on to the last shreds of your sanity. The three things I find the most troublesome on a location shoot are the wind, excessive lighting contrast and intrusive, distracting backgrounds.

*Wind tent*    Sailors need it, weathermen claim to know it, Beaufort measures it, and plant photographers hate, hate, hate it—wind. Britain's woods, meadows, bogs, burns or heaths are never still. You wait for a lull, sometimes for hours, and then the sun goes in, you go home, and when you return the flower has withered and blown away completely. Even when you cannot feel it, it is there to vibrate your subject. You need a tent! Easily constructed from lightweight wood and plastic tracing paper or bought commercially in foldaway form, such a device will at least give you a sporting chance. Although it cannot withstand severe gales, you will find it a boon in light breezes.

Make a frame 40cm × 40cm square and build it into the base of a cuboid 50cm high. Cover the top and both sides with a diffuser and the back and front with high-quality clear cellophane. Drop it over your subject and shoot through a tailored hole in the front. Replace the cellophane regularly to prevent it from getting dirty and scratched and spoiling your shots. A few 'U' pegs made from coat hangers, which you can hammer into the ground, will prevent it from being blown over and a handle on the top will make the 'loony lampshade' (my friends' nickname for it) more portable.

If you can, shoot without the back cellophane as reflections can be a problem if you have a good depth of field. With a thick grass sward you may need to do a little gardening to set the tent down firmly—carry some stout scissors but don't go wild, because the microhabitat surrounding your subject is inevitably important to its survival.

*Diffusers*    Bright sunlight, particularly high noon summer sun, is an ugly medium to have to work with. Harsh, flat and horribly contrasty, it makes grotesque caricatures of the subtleties of nature. Basic exposure of brightly lit objects can be a problem as the lower parts of the frame are plunged into darkness—the range of exposures within the scene is very high and your filmstock will never cope with it.

The shiny backs of insects and soft hues of flowers deserve a more gentle approach. Being small (thus needing a macro) and prone to scuttling or vibration (thus needing a high shutter speed), lots of light is necessary; but harsh sunlight can be transformed into a coat of gossamer radiance by nothing more than a piece of old tracing paper

Make a stout wooden frame, 50cm × 50cm, firmly fixed at all four corners and pin on a couple (test to taste) of sheets of tracing paper. Add a handle on one edge for portability and take a few 50cm rods as useful props for your canopy in the field. Erect it like a lean-to over your subject or set and, for the loss of one or maybe two stops, you will achieve truer colour rendition of a multitude of different subjects.

*Background boards*    Another helpful and portable aid to macro photography in the field, particularly when snapping herbs and flowers, is background boards. Often you find yourself faced with an eyesore for a background—a chainlink fence and litter, or something similar in colour to your subject or something that clashes horribly with it. Slight gardening is acceptable, but pulling down fences and uprooting a plant's nearest neighbours are out—so why not just take your own backgrounds?

Get hold of a couple of sheets of board 50cm × 50cm square, and cut a hole in one side for a handle. Then paint each side in a choice of dark brown, dark green and mottled yellow, green, black and brown (use car spray cans for the mottling to avoid harsh edges). This will enable you to use a large enough depth of field to keep your often small subject sharp, but will allow you to frame it against an out-of-focus background. Without this everything to the horizon would be sharp, too, and interfere with your subject.

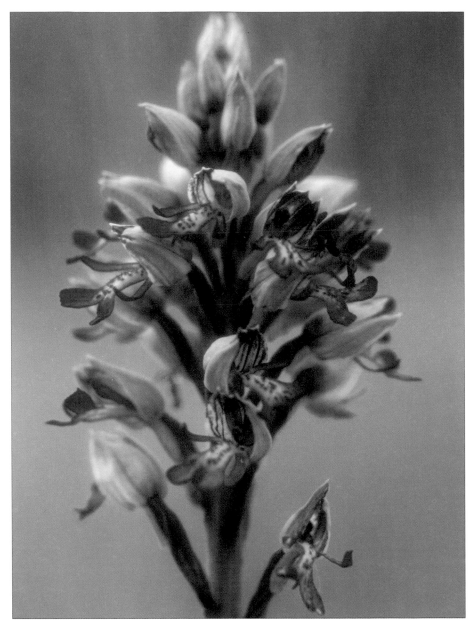

**Military orchid** (right)
*Canon F-1N, 100mm macro lens, softener filter, tripod with cable release, wind tent, Kodachrome 64*

**White water lily** (opposite)
*Canon F-1, 100mm macro lens, tripod with cable release, Kodachrome 64*

are said to resemble small, elaborately uniformed soldiers, their chests emblazoned with small tufts of purple hairs—buttons or medals, I suppose. This species is specially protected under the Wildlife and Countryside Act of 1981, but also seasonally by a team of round-the-clock volunteers who guard against the selfish lunatics who would otherwise transplant them to their private nurseries. In fact, this chalk-loving plant was thought to be extinct during the early part of this century until two colonies were re-discovered in 1947 and 1954 in Buckinghamshire and Suffolk respectively.

The second plant portrait is a close-up of a white water lily bloom—a gracious July offering well worth getting wet for. The trusty, never rusty, Benbo jambed into the mud of a New Forest pond provided stable support for my macro close-up of its waxy white petals and frosty yellow stamens.

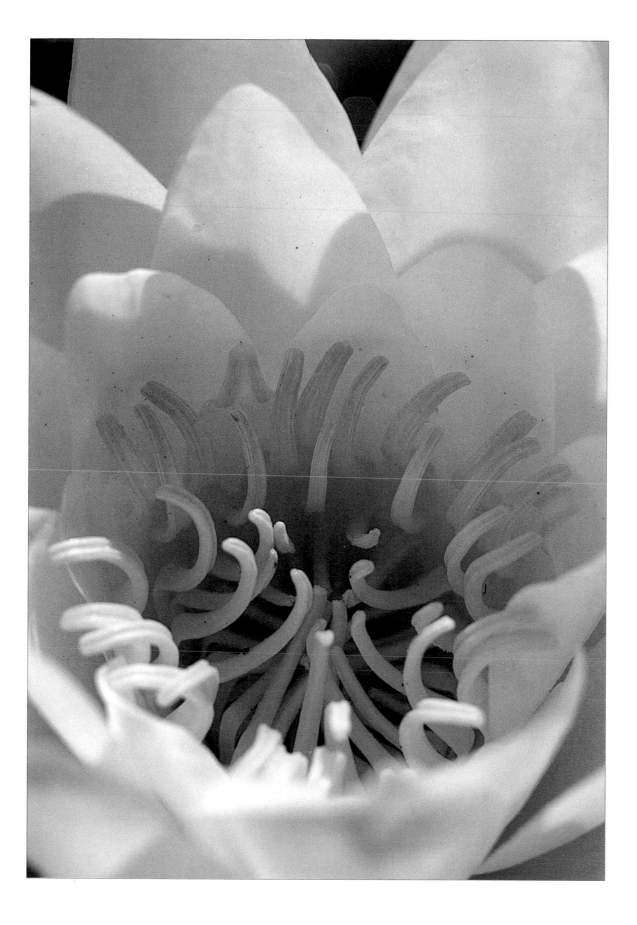

# Magic Mirrored Mushrooms

TOADSTOOLS ARE NOT PLANTS. They are the fruiting or reproductive organs of fungi, the body of which is rarely seen as it is a creeping mycelia—a cottony thread—running through the rotting debris that provides its sustenance. By peeling bark from long-dead logs or rummaging through leaf litter you may find some of these matt-white cottony threads, but they will certainly not excite you photographically. The toadstools certainly will, though, especially when they sprout forth in their thousands during the damp nights of September, October and November. These fragile soft structures come in all shapes and sizes. Some are edible, some extremely toxic, some dry, some slimy, some terrestrial and some arboreal. There is a great British fashion for the local naturalists' society to hold fungus forays each autumn, whereby hordes of eager mycologists scour our woodlands filling plastic garden trays with all the specimens they have picked. What thoughtless vandalism! I am sure the same people would baulk at snipping wild flowers, yet what is the difference? In fact, given the fungus's more sensitive reproductive requirements, they should be held even more sacred and therefore treated with greater care and consideration.

## Brittle brollies

FOR THE SHOT overleaf of the underview of a clump of porcelain fungus, I laid a mirror against my bean bag half under the umbrellas of the fungi and, to enhance their gills, shone a torch through their tops. I set my camera on the tripod, focused on the reflection, and experimented with different densities of illumination and the f-stops this afforded. Mirrors (and lenses!) need regular dusting in musty old woodlands and an anti-static gun or cloth as used for old vinyl records is a real asset.

## SILVER SURFACE MIRRORS

LOOKING AT the photograph overleaf you may be forgiven for thinking that hypocrisy has gripped me. Underviews like this are not normally possible without digging humongous holes in the countryside or picking the fruiting body. In fact, all three fungus photographs in this section were taken on the same day, using a mirror and my bean bag. They show reflections of the fungi and thus avoided any destruction, saved a fortune on hiring a JCB and prevented a hernia. Don't run for your bathroom reflectors, however, because normal domestic mirrors are no good. Such glassware is designed to be long lived and hence the reflective silver layer is on the back of the glass—i.e. you look through the glass to see the reflection. Silver-backed mirrors fail photographically because they produce not one, but two, images—one from the mirror surface and one from the glass surface. In your photographs a ghost image will appear and ruin the shot.

What is required is an object called a silver surface mirror. Quite obviously, the silver here is on the surface and a single reflection is obtained. Shop around for one of these quite expensive accessories and then make or buy a strong, soft-lined bag to keep it in. A single mote, scratch or dirty mark on the surface will ruin your photographs, so take care.

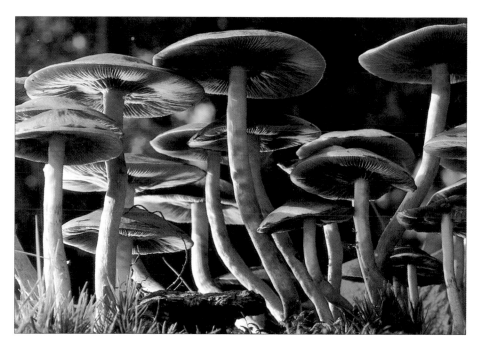

**Sulphur tuft fungus** (left)
*Canon F-1, 100mm macro lens, tripod with cable release, bean bag, silver surface mirror, Kodachrome 64*

**Porcelain fungus, underview** (overleaf)
*Canon F-1, 100mm macro lens, tripod with cable release, bean bag, silver surface mirror, Kodachrome 64*

## Sulphur tufts

THIS SHOT (ABOVE) SHOWS a side view, again a reflection, of a clump of sulphur tuft fungus growing through a carpet of rich green moss, only about 50 metres away from the previous subject. This species can be found all year round on the stumps of both deciduous and coniferous trees, although autumn sees its peak appearances. It actually smells very 'mushroomy', but is inedible—a common trait in our fungal fauna which should act as a warning to nibblers! Again I enhanced the gloom of October woodland with 'sunlight' from my torch, but feel that I went over the top here with the angle of incidence —the light is too low and looks artificial.

**Toadstools on tree stump** (below)
*Canon F-1, 100mm macro lens, tripod with cable release, bean bag, silver surface mirror, Kodachrome 64*

## Fifties fungi

AT THE END of the morning I shot the photograph right of unidentified toadstools growing on a stump. Mirrors reflect light on to your subject, which is helpful for exposure, but can look unnatural. Here, this unnatural quality has been accentuated by the colours. To me it looks like one of those horrible 1950s hand-coloured black and white postcards of the sort that portrayed James Dean, Tony Curtis and Marilyn Monroe in gaudy reds and blues on lawns of ultra-green grass. The even lighting and even colours appear very similar; in fact, they make it look as if it was snapped in a studio using a Bakelite camera and antique Eastman film.

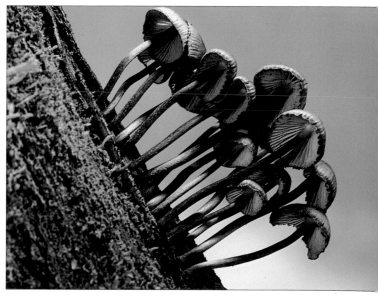

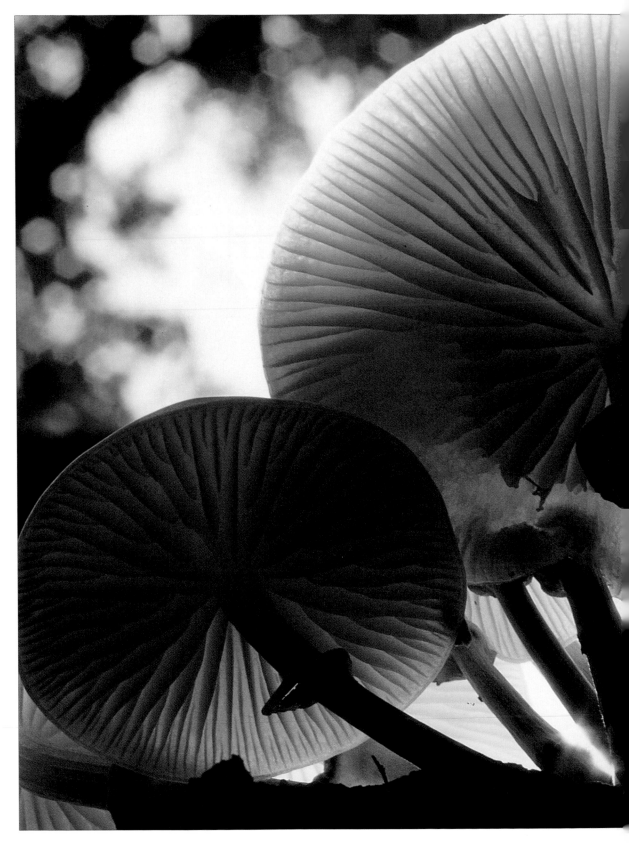

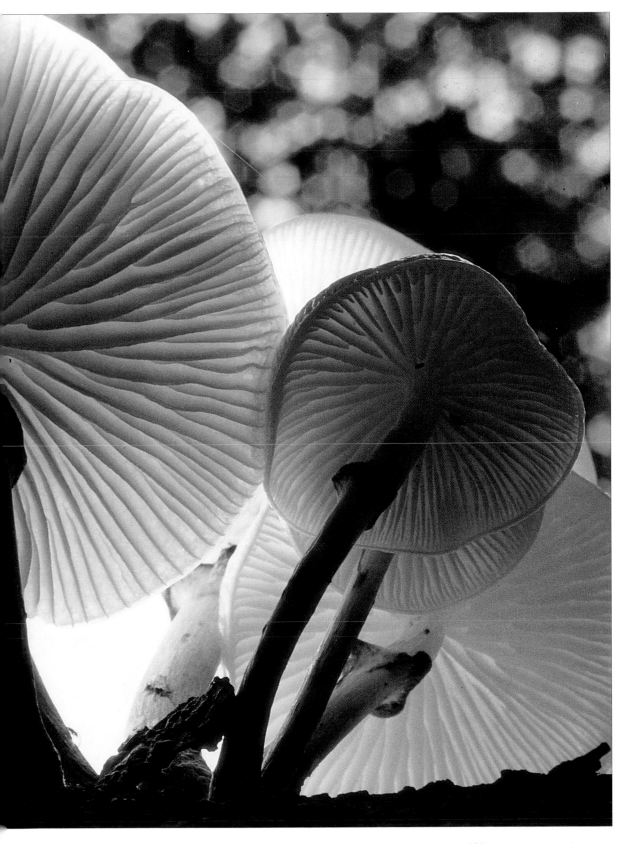

# The Spirit of Woodland

THE SELF-ASSIGNMENT is a good way of focusing your attention on a project or subject whilst excluding the tempting myriad of other topics from their distracting intrusions into your developing photographic eye. You may have known a place or species all your life but I assure you that when you start peering at it through a lens you will see a lot that you have missed, particularly if you are asking for some new or exciting approach. Be reasonable with your choice: the mating habits of dugongs are not really a feasible first assignment; and besides, dugongs are dead ugly. Choose a back-garden bird or bug or a local park or habitat you think you know. This gives you a chance of success at a time when you should be most hungry for it.

This section includes ten photographs from my second photographic self-assignment entitled 'The Spirit of Woodland'. All were taken within 15 miles from my home over two seasons in places I have known all my life, yet I count a couple of them as among my best photographs. Of course, I was happily snapping all and sundry at the time, but I soon couldn't get near anything at all 'woody' without consideration of its potential. Several of the pictures are second or third attempts to convey what I wanted to express photographically. Thus I had to implement new techniques. I had to pre-plan shots and recce sites, but most of all I had to look again at woodland. I saw things I had missed, learnt a lot about the habitat and how to record it and saw how to enjoy it aesthetically. Reaching a romantic extreme, I tried to embrace and rejoice in the spirit of woodland. Well, here are the photographs.

## Heart of England

BEGINNING WITH BASICS I began by photographing portraits of trees and this picture of a large spreading oak was my best attempt. As a single tree it does not really qualify as woodland but I had a problem with trees in the plural. The trouble is that in woodland you can't see the trees for the wood. They all overlap and make ugly uncomfortable intrusions into each other's space and your frame when you try to isolate a subject. Whilst tree design is a triumph of form and function through evolution, they are pretty untidy and imperfect aesthetically; and as someone who was trying to simplify everything for his assignment, this was more than I could bear. After a few sweaty mornings battling through bracken and brambles I fled the wood to the

fields where I could take more artistic control without the help of a chainsaw. Quintessentially English, the pendunculate oak, *Quercus robur*, stirs patriotism in the heart of even the most recalcitrant Briton. As one of our most ancient tree species it attracts a whole host of invertebrates (more than 400 species) not to mention a bevy of birds and a hat full of mammals. Given no human interference, oak woodland would be the dominant form of vegetation over much of Britain in as little as 90 years.

What attracted me to this shapely specimen was the intense contrast between the thick midday shade cast by its canopy and the rich riot of yellowy green in the lush meadow. By cropping in on the lower boughs and balancing this with their shadow below I have left a sunstrip split only by its sturdy trunk. Aside from the symmetry and colour, impossible to achieve in woodland, the shade is an important element as it reflects the success the thousands of leaves have had at intercepting light.

**Oak in meadow**
*Canon F-1N, 70–210mm zoom lens, tripod with cable release, Kodachrome 64*

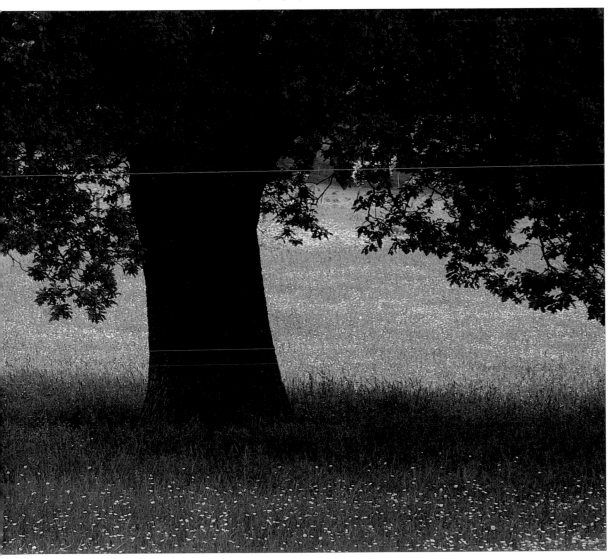

# Button moss carpet

TWO THINGS drew me to this scene near Boldrewood in the New Forest: the rich uniform green of the mosses on the ground complemented by the algae on the tree, and the marvellous texture of the woodland floor covering. To be honest, this photograph was enhanced by some 20 minutes of rigorous gardening. When I arrived and perched my camera and tripod precariously on the top of a fallen tree trunk near by, the view was complicated by a mat of untidy and visually distracting fallen twigs. I composed my shot using the zoom lens, and then, when I had confirmed the exact framing of the photograph, I crawled about on my hands and knees hoovering away the irritating detritus. Slowly but surely the soft bed of button moss became less prickly and more uniform in both colour and texture, until I picked the second-to-last twig from the very top of the frame some distance from the back of the tree. I returned to the camera and took about eight shots in varying light—overcast sunlight, cloud and full sunshine. Although I needed a long exposure on the cloudy shots in order to keep the aperture small and thus maintain a good depth of field and keep all of my moss-tiled floor sharp, I felt that this simple mosaic worked most successfully. Sunspots were impossible to accommodate in terms of exposure and led either to very pale green patches or to a blackened carpet starved of its verdant spring greenness. The paucity of a ground layer again illustrates the efficiency of the

**Beech stump and moss-covered ground**
*Canon A-1, 70–210mm zoom lens, tripod with cable release, Kodachrome 64*

tree canopy above in interrupting the available light, although here this particular forest feature is exaggerated by the gross overgrazing inflicted by the ponies and deer that ravage the New Forest ground flora.

## Light grabbers

HOW ABOUT THIS for plant production— dog's mercury and bluebells in abundance on a 2-metre area of an oak/hazelwood floor in early May. At this time of year the plants have just a few weeks to complete their cycle of growth before the hazel and oak canopies close over and block out the light; and in these freshly coppiced woods near Winchester, dog's mercury and blubell have literally gone berserk. I knew the site well and conceived this picture in the winter: low morning light to backlight the leaves, producing bright green teardrops and black shadows; a large dense area with no interfering stumps, clear of shade from overhanging trees; and a medium-length telephoto stopped right down to produce a thick, green tapestry of plants. When the leaves are fresh they are greener than green. If you had painted this view in oils, critics would say that the colours were too vibrant; yet here the dog's mercury is sucking up sunshine and shining brilliantly in its success.

Shot on Kodachrome on a slow exposure to maintain depth of field from front to back, the inclusion of bluebells was a slight problemette. I considered

**Dog's mercury and bluebells**
*Canon A-1, 70–210mm zoom lens, tripod with cable release, Kodachrome 64*

grubbing them out, but so dense was the sward that any intruding footsteps would have damaged the uniformity of my shot. Thus I chose a view with as few intruders as possible and experimented with various degrees of blue filtration to re-establish their true blue colour on this red-biased film. However, the blue destroyed the remarkable green so I have stuck with this photograph with its scattered pink bells.

This picture and the previous one are both concerned principally with the chlorophyll molecule and its verdant colour. Secondarily they illustrate how shade affects the structure of our woodlands. Both are fairly abstract, reducing each vista to a patterned mosaic.

## Total impression

IN THIS PHOTOGRAPH I have taken image destruction to the greatest extreme that you see illustrated in this book. I make no apologies, because my aim was to reproduce a hazel/bluebell woodland as we see it. Opposite is a conventional

**Bluebells in hazel wood, impression**
*Canon F-1, 500mm mirror lens, tripod with cable release, blue filter, Kodachrome 64*

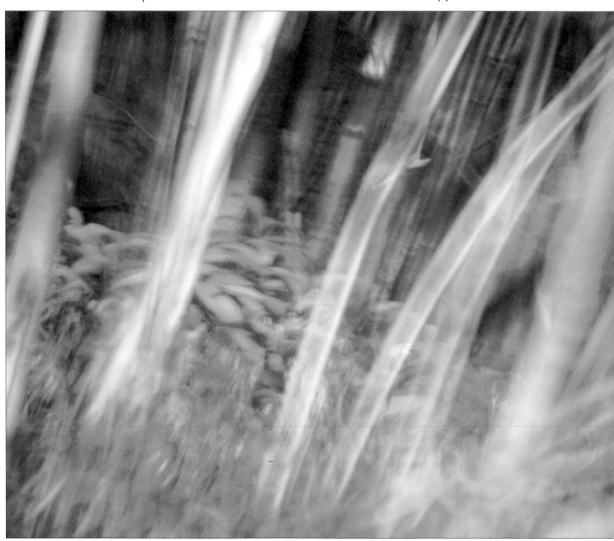

photograph of a bluebell wood in early May—properly exposed, colour corrected and not, in my opinion, what any one of us sees when we stand in such a splendid habitat. I took a stack of these shots one day and then got half-way home and realized I had wasted my time and film. We do not see each tiny flower, each spiky leaf, each vertical pole of hazel, all the intruding Solomon's seal and dog's mercury. We do not have pin-sharp 28-mm eyes that record all in a fraction of a second. I returned to try and establish exactly what the human eye does see, but could not satisfy my optical quest at all. Then on my way home for the second time I tried to deduce not what I had seen but what I actually remembered of this piece of woodland, the most prominent visual impressions that it had left with me. The photograph below left is a fairly satisfactory encapsulation of these impressions. You may feel that I must be short-sighted with a twitch, but at least let me explain my impressionistic vision!

There is a dense carpet of uniform heavy blue, bluer than reality because

of its striking dominance of the habitat and aesthetic appeal. There are intrusions of thick green, a few more straggly, less regimented plants which stand above the carpet and act as a transition between the floor and the canopy above. Then there is the background and canopy itself, distant and very dark, already a near black–brown, which sheds no sky onto the scene. Between these components there are the hazel trunks, rods of pale timber straight and sturdy.

To reproduce my impressions, I had to destroy the pin-sharp image that I had previously recorded. I used my 500mm f8 mirror lens to narrow the views and compress the colours, and to enhance this aspect further I underexposed by half to three-quarters of a stop for better saturation of the blues and greens. The blue was corrected and enhanced by a strong blue filter taped to the front of my lenshood. Looking through my camera I could still see detail, detail which I had not remembered, so I huffed on to the front element and, during a slow exposure, wiggled the lens to reduce any sharpness that remained. I also tilted the frame slightly to improve the composition.

You either like it or loathe it. I could fill another volume with photographs of this sort, some of which make this one look rather moderate, but this shot illustrates a real attempt to find a photographic solution to a perceptual and artistic problem. Whether you feel it also illustrates a hazel/bluebell wood is another matter. Remember, Joán Miró tried to destroy art by painting. A brief foray into the destruction of photography via Kodachrome may prove enlightening!

**Autumn bracken**
*Canon F-1, 28mm lens, tripod with cable release, Kodachrome 64*

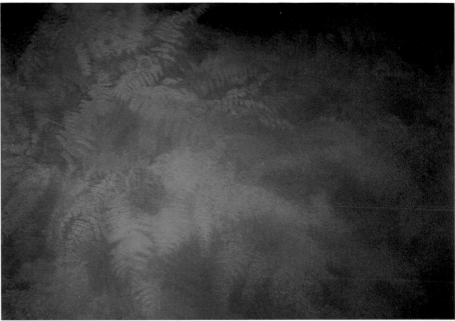

## Dream of decay

THIS PHOTOGRAPH of decaying autumn bracken is very similar to the previous shot in its impressionistic approach. The colours are a bonfire of burning green, flaming yellows and spent ochres. This is a slow explosion of the plants' death, a sad palette of lost sap and strength, but what a glorious spread it makes each year through our woodlands. I had seen these scenes one day as I travelled home by train and set out the next morning in a mist of damp drizzle. I saw this photograph and set up my camera to record the moment. Just as before, my camera had a different eye. It cleared the mist away and gave me sharp edges. It was immune to the musty smell of this bank of dying plants, it dispelled the chaos of decay as copper bronze and brimstone melted together, it could not see the dynamic corrosion that I could.

Had I just snapped the above scene it would have been nothing, perhaps a useful background for a trendless magazine to drop pictures of rutting deer over, just a happy snap in the forest; but I huffed and I puffed and I blew my damp breath on my wide-angle lens and, as the condensation cleared, shot six frames on my auto winder. This is the best one and it is my favourite of all the plant photographs included in this book. The mist and drizzle that cloaked that October morning have returned and shrouded the leaves, and I enjoy peering through the mix of greens and golds for the little vermiculations that betray this spillage as bracken—following the flames to find form.

## Foxgloves

FROM JUNE ONWARDS the thick purple spikes of foxgloves are a feature of woods of all kinds countrywide and are a favourite with pollinating bumblebees and ramblers alike. The whole plant is poisonous, its tissues being filled with a mix

**Foxgloves**
*Canon A-1, 70–210mm
zoom lens, tripod with
cable release,
Kodachrome 64*

of glycosides including digitoxin, known to herbalists as digitalis, which affects the muscles of the heart. However, this fact is of little consequence. The bees are unaffected by the nectar and I cannot imagine that many ramblers feel peckish, make a foxglove sandwich, and die of cardiac arrest.

I chose foxgloves as an archetypal woodland flower and, as the ramsons, primroses and anemones bloomed and withered, waited to photograph them. But when the foxgloves themselves flowered, my photographic mind would not engage. I had envisaged a blazing fountain of purple shimmering in a sunspot deep in a black pinewood but, despite hours of driving around peering into plantations, I couldn't find this specific vision outside my imagination. I considered a transplanting exercise to a ripe glade but couldn't even satisfy this requirement so in September, when the last few mauve trumpets fell from the twisted tips of the stalks, I finally admitted defeat. In fact, I even forgot my quest until I visited Skomer Island off the south coast of Wales the following July.

This small island is famous for its seabirds rather than its woodland; indeed, there is only one tree growing there—a rather stunted but rare black poplar. In one of the marshy stream bottoms. However, a huge bed of foxgloves was flowering. They looked bland in the midday sun, so I returned each evening as the sun set to get this backlit shot, the light adding a silver edging to each frond via its down of tiny hairs. Wind was the inevitable enemy on this open, flat-top island, and consequently I could not do what I really wanted which was to produce a spiky sharp mosaic by utilizing a large depth of field. The fast shutter speed needed to freeze the wavering stems gave a shallow depth of field and to my mind this has reduced the impact of the picture. I did succeed with some similarly lit red campion adjacent to the foxgloves but despite extensive searching I cannot find the best shot anywhere.

## IMPROVIZED FILTERS

Y OU CAN BUY graduated filters in a range of hues and elaborate holders to hold them in front of your lens, but such contraptions are too bulky to bother with all of the time, so I always have a box of multi-coloured gels about 15 × 15cm and scissors and masking tape to cut and stick where necessary. This is a cheaper, more practical approach to filters, as is dabbing an old UV or skylight filter with Vaseline to produce a soft-focus effect. Using this method you can arrange zones of soft focus precisely to fit your final frame. Commercially sold soft filters have dimples which create increasingly unpleasant blotches the more you stop down. This can be a real problem in macro mode when you may need a good depth of field to keep your subject in focus but still want it all soft.

Overuse of filters, particularly the bright colour-enhancing variety, can produce really vulgar and naff results. The colours available are nearly all more 'neon fairground' than subtle natural hue, so I find that they generally work better with softening to diffuse their effect.

# Birch fires

A GLADE OF birch trees in autumn can be a dazzling spectacle. If there are no strong winds or heavy rains to blow all the leaves off the trees, they transform from thick and bushy mid-green pillows into yellowy gold lamps that glow on sombre heaths and scrublands countrywide.

At the end of a productive season of photosynthesis, a light-fuelled chemical process that green plants use to produce oxygen and sugars, these organs would be too expensive to preserve for a season of non-sunshine. Hence leaves senesce and, as the cell structures disentegrate, any retrievable nutrients are sucked out and stored in the woody body of the tree and its roots. Meanwhile the processes of chemical decay in the leaf and its stem produce a rich variety of new colours for the aesthete.

I arrived at this sunny bank looking for fly agaric toadstools, a species which regularly appears under birch and is also known as the Fairy Tale Fungus, the red and white spotted seat of pixies, elves and goblins from all over Europe. There were none here so to redeem the fungal failure I took a series of snaps of this group of yellowed trees (left). Although my eyes appreciated the sharpness of each spangled leaf, I wanted a more impressionistic feel so I used two softener filters to spread the colour about. I even added a little more yellow with a piece of yellow gel, taped over the top half of my lens. Of all my six shots this has the most satisfying blend of yellow, blur and light, but I have always felt I could find a better glade with a more pleasing composition to improve the concept.

**Birch trees in autumn**
*Canon F-1, 50mm lens, tripod with cable release, yellow and soft-focus filters, Kodachrome 64*

# Endless cycles

VERY LITTLE needs to be said about the photograph on the next page, which shows a tightly framed composition featuring a textural abstract of a scarred trunk. Whilst woodland can mean vibrant glades exalting in a great abundance of living tissue in the sunshine that feeds its light-absorbing factories, it is also about a huge cycle of minerals and nutrients and thus death, decomposition and decay are as much a part of its story. On a bleak and rainy winter's day I saw this algal-washed log and used my zoom lens to exclude the misery of my surroundings. The pocked and split timber is powdered with a range of greens reminiscent of the oxidized residue of copper corrosion, which adds a living colour to a dead giant in a very pleasing fashion. As usual, I have underexposed the slide film a little to improve the colour saturation.

**Close-up of tree trunk**
*Canon F-1N, 70–210mm zoom lens, tripod with cable release, Kodachrome 64*

146

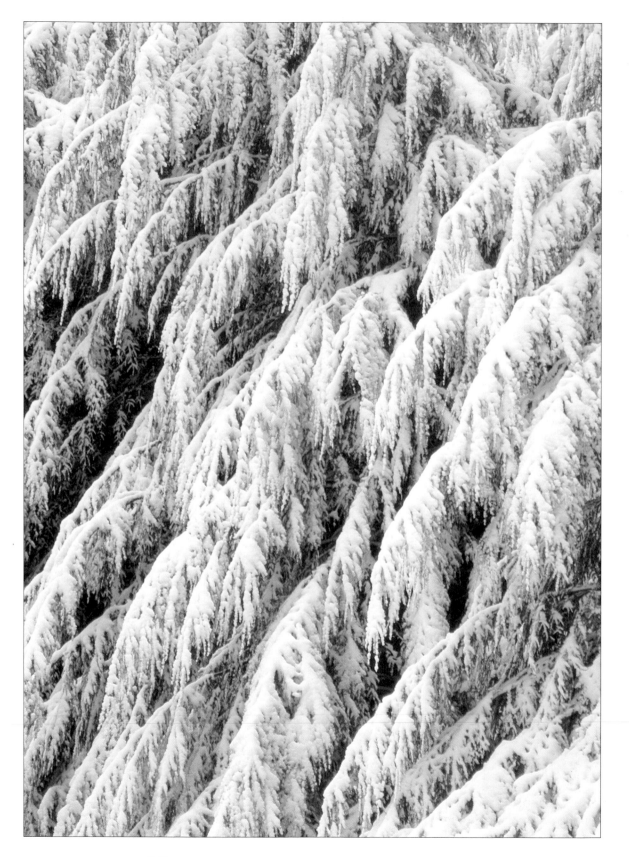

# Snowfalls

NOT A CLOSE-UP of a frozen Niagara (left) but a snow-sided pine illustrating the tree's excellent adaptation to the burden of heavy winter conditions. With its downward-flexing boughs the tree has almost been tiled by the snow which will now fall off having cocooned and insulated the important trunk inside from searing winds and frosts. However the physiology held no real interest to me when I took this shot on a New Forest roadside. I was attracted by the strong diagonal composition, the pleasing soft texture of the ice sculpting on each bough and the monochrome tones of the late afternoon light. As usual I bracketed a little to account for the snow fooling my camera's light meter, and varied the size of my shot with the zoom to make the most dynamic use of the pattern and detail. Simple to take and simple to please. Before I left I saw the next photograph alongside it.

**Detail of a pine covered in snow** (opposite)
*Canon F-1, 70–210mm zoom lens, tripod with cable release, Kodachrome 64*

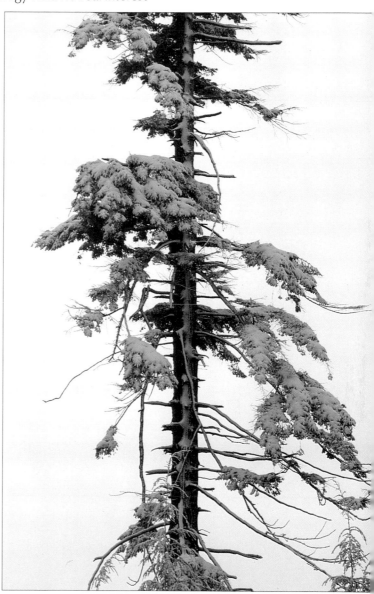

# Monochrome pine

I HAVE ALWAYS liked the monochrome nature of this portrait of part of a pine tree (right). Disguised the same grey white as the snow caught on its branches and all the darker boughs, trunks and shadows are of the same grey brown. Two very soft colours in a late afternoon light. It has reminded me of a watercolour or pen and ink study or even a Japanese silk-screen print. The tree is interesting with all of its straggling and snapped spiky branches, and a huge wall of snow welded on to trees behind the camera has reflected a lot of light back on to it. This has softened the contrast and produced a very unusual effect; without it the tree would be no more than a silhouette in a bleak January sky. At the time I fantasized about a characteristic profile to provide a little sub-subject, perhaps a buzzard or a goshawk perched on one of its exposed spurs, but in the end I decided I was perfectly content with this unusual portrait of an old tree.

# Abstract Images

I HAVE OUTLINED and tried to justify my image destruction to imitate Impressionism with photographs such as those on pages 126 and 140. Here I offer five more photographs in a similar genre. By isolating a subject and

**Portrait of a pine covered in snow** (above)
*Canon F-1, 70–210mm zoom lens, tripod with cable release, Kodachrome 64*

**Ox-eye daisies and red campion**
*Canon A-1, 70–210mm zoom lens, tripod with cable release, Kodachrome 64*

**Cross-leafed heath**
*Canon A-1, 28mm lens, hand held, Kodachrome 64*

focusing sharply on a single aspect of its form, or by simply choosing a view which is normally invisible perhaps because it is so small, we can produce abstract images.

## Car-blown blooms

THE SWIRLING bouquet above left was taken on the verge of the Marchwood bypass near Southampton. This major roadway is decorated each spring by a generous sward of ox-eye daisies and red campion, which are buffetted in the smoky wake of countless thousands of passing vehicles. I observed this in a sulky stare from my own car window as I was being driven home having been thrown from a horse. The next day, suitably fit, I returned. I set up my camera on the opposite verge and, working my way dangerously down towards Fawley, shot a whole roll of variously blurred blooms on exposures ranging from ¹/₁₅ second to 2 seconds As each car or truck passed I waited until it was level with the camera before squeezing the shutter release on the camera. I had a few blurred bumpers and this, the most attractive wash of colour. I have another denser shot of just daisies which looks like a plate full of fried eggs slipping off a green tray.

Both ox-eye daisies and red campion have long stalks and are thus easily blown about, leaving long traces of colour. Shorter and stouter stemmed species tend only to quiver and look like mistakes. I am sure this shot could be improved upon.

## Heath firework

THE PHOTOGRAPH above shows a top view of a dead cross-leafed heath plant shot on the same afternoon as my adder portrait (see page 70), in the same place as the lichen and ram's skull (see page 13). It illustrates the natural cycle of this plant's growth (there are a few green fronds already creeping through this sprawling wreckage). Using a wide-angle lens and climbing on top of a metal camera case I shot this straight down at the ground just excluding my own feet. I have always liked this shot for its black and white qualities and resent the intrusion of the green shoots which I failed to notice at the time. Had I spied these I am sure I would have grubbed them out to enhance the purity of the image. The wreckage looks stiff, sharp and brittle, as it really is, and yet the plant looks as if it has also been caught in a moment of motion brilliantly flashed by lightning. Very pretentious, eh?

## Wet grass fans

MANY SPECIES of grass are very simple plants. Most have narrow lamella leaves, a straight stem and flowers that have been replaced by grass flowers composed of leafy bracts; there are no showy colourful petals and only occasionally does ripe pollen add a more vibrant hue. Despite this they can be very attractive and make ideal subjects for silhouettes or as uniform or sculptural backgrounds for other species. In the photograph above and those that follow, however, the grasses stand alone—or, in the first shot, lie alone on a thick blue pool of water. Taken in a flooded fieldside after a night of heavy rain, the light was just right to make the water surface a mirror,

**Flooded grasses**
*Canon A-1, 70–210mm
zoom lens, tripod with
cable release,
Kodachrome 64*

darkened by black mud beneath, yet snatching a hint of royal blue from the
clear sky above. From any angle other than looking straight down on it, the
pool was a bottomless sea of ink. In contrast, the brilliant green leaves of the
grass make a verdant palm on the surface. The grass looks so fresh, so edible,
so new, neat and simple. I took about ten shots of this particular puddle,
much to the dismay of my birdwatching colleagues who were impatient to
chase after a buff-breasted sandpiper, a long-lost vagrant which remained so
despite three or four hours of frustrated searching! Again I like the
photograph, probably through a sense of having made a picture from
nothing when I didn't plan to. You may of course see it as a tuft of grass
floating in a puddle, I suppose—and once again, it could be improved upon.

153

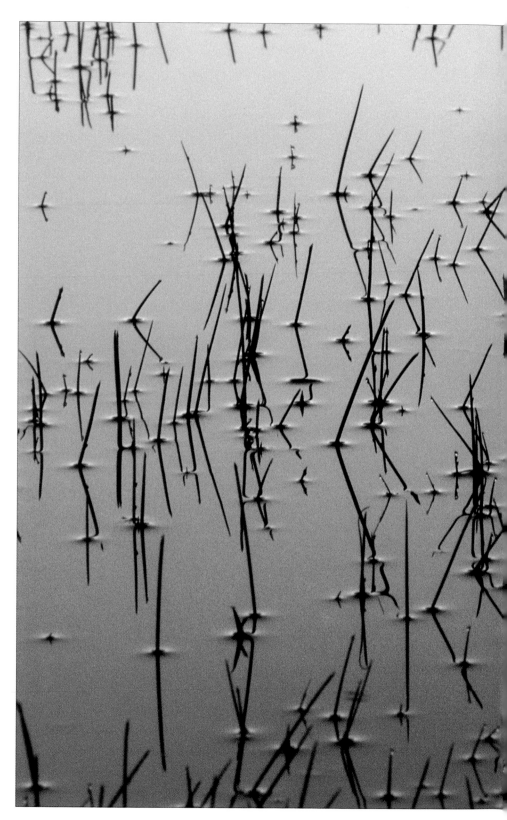

**Sheep's fescue**
*Canon A-1, 100mm
macro lens, bean bag
with cable release,
Kodachrome 64*

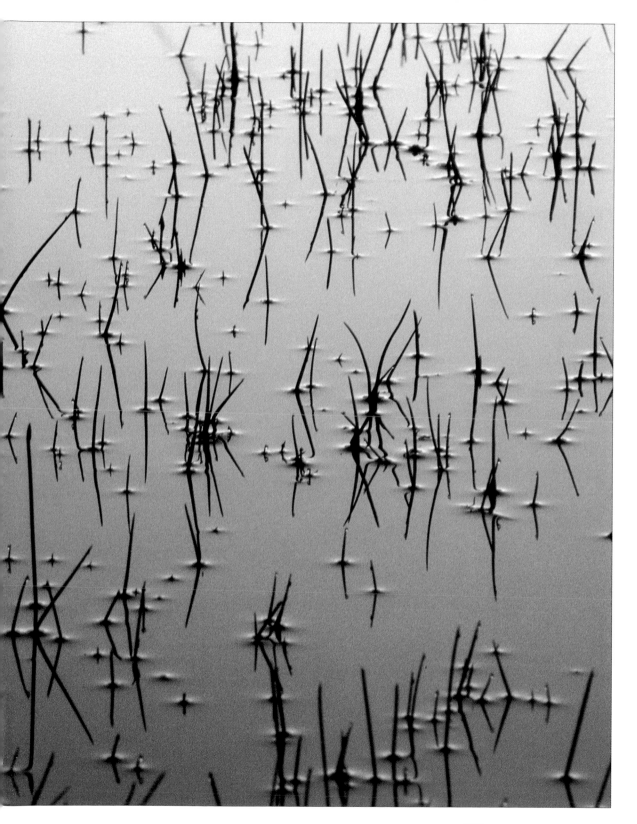

## Prickly pool view

PUDDLES OF GRASS again caught my eye and I took the extreme close-up on the previous page of a heathland pool at sunset in Suffolk one summer. This is more about texture than salad viability, and is more monochrome, the grass tips reduced to tiny spikes of black, prickly needles that might be nice to press against with the palm of your hand. The low, post-sunset light has again made a mirror, punctured and recurved by this bed of sheep's fescue. The whole area shown in the photo is probably no wider than ten centimetres and not deeper than twenty. In fact I was looking for a reflection of a whole tree when I crouched down and spotted this mini-scene. The bean bag served well but subsequently became wet and swelled as the split peas expanded into a squidgy mulch. A polythene bag would have saved the day, but as usual the shot was more important. Total stillness allowed me to use a very long exposure and flatten the perspective to make more of a mosaic than a miniscule vista.

## Molinia seedscape

THIS SHOT was planned in the wintertime, looking through a book on grasses and remembering a patch of dry sandy heath that bakes behind my friend's house near Brandon in the Brecks. It is no more than a patch of Molinia grass, a species that is common on the sandy soils in this area. Taken in the heat of the afternoon without any hint of movement, each bright seed head has been transformed into an explosion, a firework given scale and dimensions only by the diffused fronds of bracken visible in the top right corner. The photograph is of little and says little about little, but has always been one of my favourites for its very simplicity.

**Molinia grass**
*Canon F-1N, 70–210mm zoom lens, tripod with cable release, Kodachrome 64*

# Bibliography

Campbell, B and Martinez, R (eds.), **The Great Photographers**, (Collins, London, 1983)   Cheap and well printed, these paperbacks give a good introduction to each photographer's work through a portfolio of pictures – a valuable starting point before you go on to beg, borrow or steal more detailed and expensive tomes. Portfolios by Ernst Haas, Cartier-Bresson, Man Ray, Pete Turner, Don McCullin and Cecil Beaton.

Campbell, Laurie, **The Wildlife Photographs of Laurie Campbell**, (Colin Baxter Photography, Lanark, 1987)   Laurie Campbell combines an artistic eye with that of a good naturalist and rarely manipulates any subject, preferring to shoot entirely in the field.

Dalton, S, **Borne on the Wing**, (Chatto & Windus, London, 1975)   Although Dalton has published many books since, this remains undated and a classic. Its unique pioneering perspectives in ultra high-speed reveal fascinating details in everyday subjects that would otherwise for ever escape the human eye. For naturalists it is a revelation and for photographers an inspiration.

Earnest, D and Bulzone, M (eds.), **Landscape Photography**, (Phaidon Press, Oxford, 1984) This beautifully produced book again provides an inexpensive peek at the work of eight of the world's most famous landscape photographers. Portfolios by Harald Sund, Yuan Li, Sonja Bullaty, Angelo Lomeo, Franco Fontana, John Chang McCurdy, Steven C Wilson and Shinzo Maeda.

Haas, Ernst, **The Creation**, (Penguin, New York, 1971)   Ernst Haas was a 1960s and '70s master who applied himself to natural subjects. From slow-speed impressionistic ghosts of wild horses, colour-spun sculptures of bullfights and miraculous reflections to abstract landscapes made from a fragment of mother of pearl, this is a valuable source book for anyone looking for the spring of art in nature photography.

Kendall, R (ed.), **Cézanne by Himself**, **Degas by Himself**, **Monet by Himself**, **Vincent by Himself**, (Guild Publishing, London, 1985, 1987, 1988, 1989)   These are well printed folios of each artist's most famous works. To understand how colour, texture, tone, balance and every other aspect of composition work, look no further than these plates.

Lanting, Franz, **Feathers**, (Graphics Art Centre, Portland, 1982)   The modern master. This brief book of birds unfortunately has a few 'turkeys', but its beautiful abstracts and imaginative approach remain unspoiled. Feathers does not contain all of Lanting's best work – search for this in magazines and other compilations.

Walther, I F (ed.), **Taschen Art Series**, (Taschen, Cologne, 1987)   Cheap, concise and well printed, each volume provides a good visual insight into the artist's life and work. Transfer these to your chosen subjects to discover fauvism, impressionism and surrealism in your own back garden. Volumes include Matisse, Picasso, Renoir, Van Gogh and Lautrec.

Waite, C, **The Making of Landscape Photographs**, (Collins & Brown, London, 1992)   A concise analytical introduction to landscape photography, picture finding and making, with a pan-European perspective, well illustrated and neatly explained.

Williams R (ed.), **Life Library of Photography**, (Time Life Books, Amsterdam, 1982)   Numerous volumes of technique and science sprinkled with photographs by the world's greatest.

# Index